# NATURE ANATOMY

THE CURIOUS
PARTS & PIECES
OF THE
NATURAL WORLD

## JULIA ROTHMAN

WITH HELP FROM JOHN NIEKRASZ

The mission of Storey Publishing is to serve our customers by
publishing practical information that encourages
personal independence in harmony with the environment.

Storey books are available for special premium and promotional uses and
for customized editions. For further information, please call 1-800-793-9396.

Storey Publishing
210 MASS MoCA Way
North Adams, MA 01247
www.storey.com

Printed in China by Toppan Leefung Printing Ltd.
10  9  8  7  6  5  4  3  2  1

Library of Congress Cataloging-in-Publication Data on file

for my sister, Jess,
who reminds me there's
a whole world outside
the city

# CONTENTS

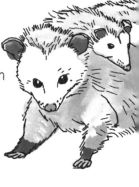

of Trees • Printing Patterns • Anatomy of a Fern • Pretty, Pretty Lichen
Mysterious Mosses • Waterbears • Mycelium • Anatomy of a Mushroom •
Marvelous Mushrooms • Rotting Log • Foraging in the Forest

## CHAPTER 5

# *Creature Feature*

Animals in the Neighborhood • Anatomy of a Bat • Common North American Bats •
Tree Squirrels • Ground Squirrels • The Lyme Bacteria Cycle • Grizzly Bear vs.
Black Bear • The Animal Underground • Snakes • Lizards • Wild Cats • Wild Dogs •
Animals with Antlers . . . and Horns • Aquatic Mammals • Outstanding
Adaptations • Marine Mammals

## CHAPTER 6

# *A Little Bird Told Me*

Anatomy of a Bird • A Bevy of Birds • Kinds of Feathers • Birdcalls • A Variety
of Nests • Extraordinary Eggs • Intriguing Bird Behavior • Birds of Prey • Owls •
Big Birds • A Variety of Beaks • Water Birds

## CHAPTER 7

# *Head above Water*

Water Bodies • Ecosystem of a Pond • A Few Freshwater Fish • Life Cycle of
a Salmon • Water Bugs • Toad vs. Frog • Life Cycle of a Frog • Tidal Zone
Ecosystem • Fantastic Saltwater Fish • Anatomy of a Jellyfish • On the Sand •
Seashells by the Seashore • Some Seaweed • Harvesting, Processing, and
Eating Seaweed

## INTRODUCTION

*A* couple of years ago, after finishing my last book, *Farm Anatomy,* and learning so many incredible things about growing and preserving food, identifying animals, and the way harvesting works, my hunger for more "green" knowledge grew. I wanted to continue my journey as a city dweller studying the natural world.

I grew up on City Island in the Bronx, in New York City, on a block that ends with a beach, as most of the streets on the island do. Collecting and categorizing shells, studying horseshoe crabs' undersides, and swallowing salt water were part of my childhood, even though we could see iconic skyscrapers glowing across the water. My sister and I spent summers at camp, hiking in the woods in upstate New York, and sleeping in tents outfitted with lots of bug spray to satisfy my over-protective mother.

I really loved nature as a kid and looked forward to outdoor adventures at every opportunity, whether it was a family vacation to Maine or a weekend trip to a neighbor's log cabin. But as I got older, I became a city girl at heart. My teenage years were spent sneaking out to nightclubs downtown and hanging out on the sidewalks of the Lower East Side. That child who loved collecting live bugs and growing crystals (encouraged by my dad, a science teacher) was replaced by a rebellious adolescent who wore black and white checkered stockings with denim skirts and chased skateboarders in Union Square.

While I live in the middle of the city, in Park Slope, Brooklyn, I am only a few buildings away from the entrance to Prospect Park, which I visit on a daily basis, most often for a dog walk or a long run. While it seems a far leap to call these tiny

journeys "nature walks." I cherish being surrounded by greenery for just a small period of time each day. It keeps me sane to be able to smell some grass after being squished like a sardine in a subway car. I really look around the park, wanting to know more. What is that tree with the beautiful leaves called? When will those flowers I saw last year show up again? Are those really bats flitting above our heads? How funny to see so many dragonflies attached, making love!

My curiosity continues to grow, and that's how the idea for this book took shape. I am glad my work has taken me back to a nostalgic place where I can begin to appreciate the things I was intrigued with as a kid.

It's about as fair to call this a "nature book" as it is to call my little walks "nature hikes." There is no way to include even a small portion of the enormous world around us in a book of any size. Where does it end? There is an infinite amount to learn about, from the constellations to the core of the earth. I guess I think of this project as MY nature book. It's the information I was interested in learning about, the things I wanted

to draw and paint. While it is only a teeny scratch on the surface, it gave me a chance to become acquainted with plants, animals, trees, grasses, bugs, precipitation, land masses, and bodies of water that I wanted to be able to name when I walked by.

My friend John has always been an influential green voice, telling me about what he cooks from his plentiful gardens, how he saved some infested fruit trees in a neighbor's yard, and how he finds ingredients in his backyard. For this project, I asked John to literally guide me on my path and show me some cool stuff I might not have found myself.

As we walked through Prospect Park one afternoon, John picked some leaves and encouraged me to eat them. I was a bit worried about what dog may have relieved himself on the plant but eventually obliged, chewing while he laughed at my reaction to the flavor. We walked through the park picking and tasting and critiquing the bitterness, sweetness, and texture of all of the edibles right under our noses. I had no idea I could make such a colorful salad from my Brooklyn park. And if this park could give us this much, I could only imagine what we could forage from actual deep woods.

If it weren't for John, this book wouldn't have become what it is, as he was my teacher and I was his student. He wrote and edited and helped me formulate ideas for the project, and I followed his lead. And while I ultimately decided what I wanted this book to be, you can find his voice on every page.

This book is now an object, a finished piece of work that we are both proud to hold in our hands. But I won't stop drawing flowers or looking up birds that I see in the park in my Sibley guide. John will continue telling me about his vegetable garden plans for next year and about the trips he takes to visit specific natural phenomena. It's a continuous lifelong project for us to appreciate our surroundings, whatever they may be, and this book is just a tiny piece of evidence of that. I hope our book inspires you to be curious about your own backyard, too, whether it's rolling hills or a flower box on a fire escape.

*Julia Rothman*

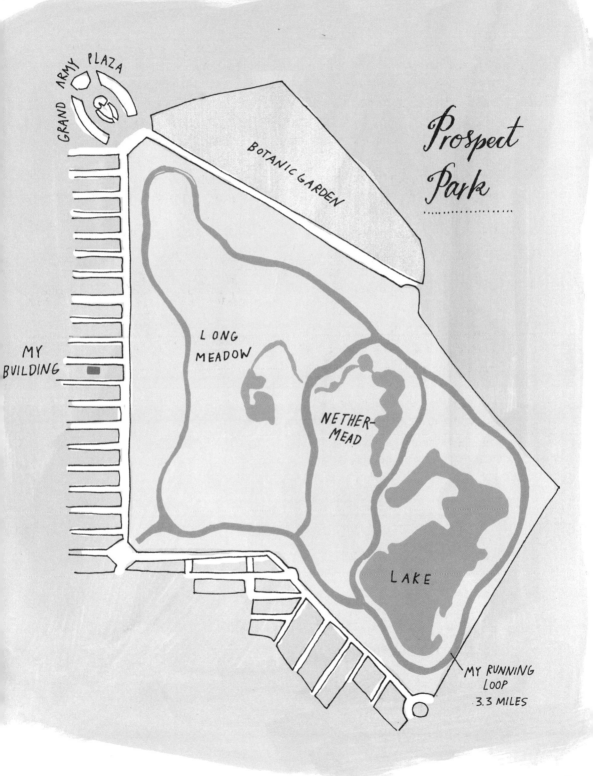

GRAND ARMY PLAZA

BOTANIC GARDEN

Prospect Park

LONG MEADOW

NETHER-MEAD

MY BUILDING

LAKE

MY RUNNING LOOP
3.3 MILES

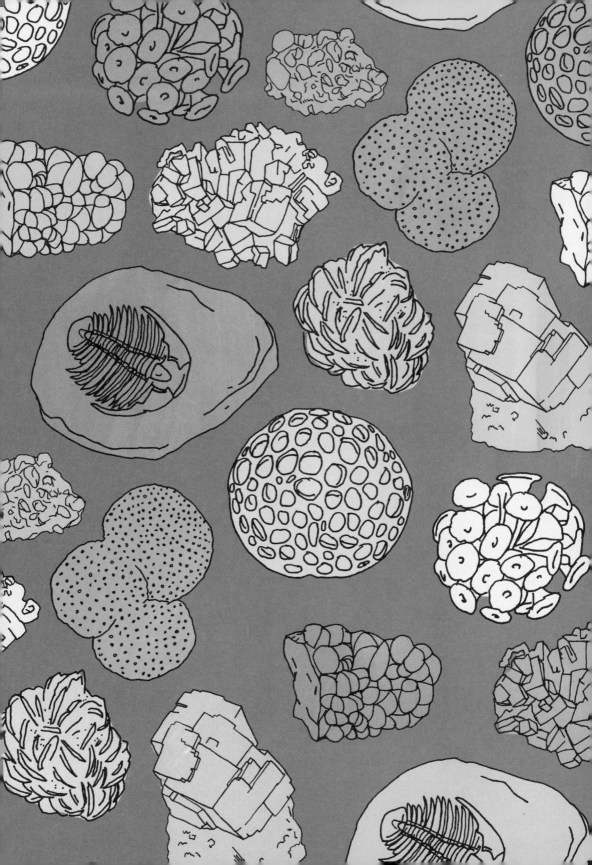

CHAPTER 1

# Common Ground

# REALLY MOVING

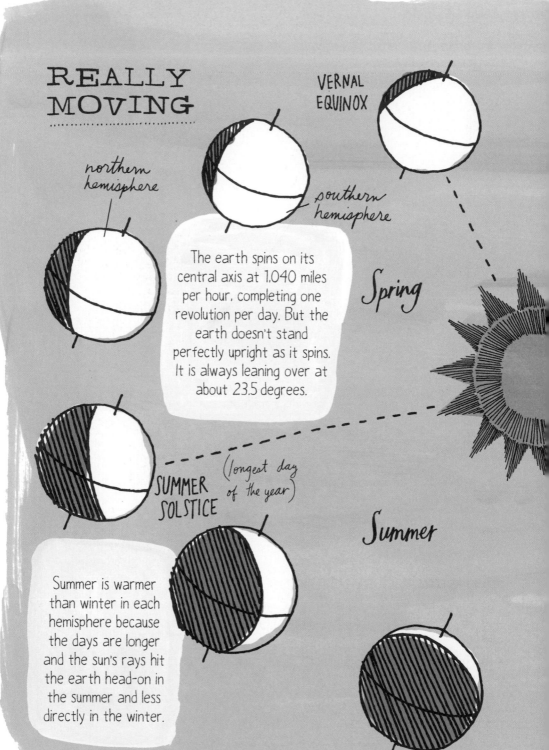

VERNAL EQUINOX

northern hemisphere

southern hemisphere

Spring

The earth spins on its central axis at 1,040 miles per hour, completing one revolution per day. But the earth doesn't stand perfectly upright as it spins. It is always leaning over at about 23.5 degrees.

SUMMER SOLSTICE (longest day of the year)

Summer

Summer is warmer than winter in each hemisphere because the days are longer and the sun's rays hit the earth head-on in the summer and less directly in the winter.

equator

Our planet Earth hurtles through space at nearly 67,000 miles per hour. Its vast oceans and land masses support more than 2.5 million species of living things, including 7 billion humans.

## Winter

**WINTER SOLSTICE**

(longest night of the year)

The differences between the four seasons — spring, summer, winter, autumn — are the result of this little tilt in the earth's axis. This tilt causes the hemispheres of the globe to face the sun more directly at different times of the year.

## Autumn

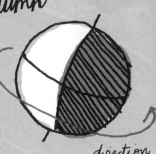

direction of orbit

**AUTUMNAL EQUINOX**

At the equinox, hours of daylight and darkness are roughly equal.

Each year, the earth completes one lap around the sun. Its 585-million-mile orbit is almost perfectly round.

# Layers of the Earth

Planet Earth was formed 4.54 billion years ago. Most of what we know about the structure of Earth comes from studying the seismic waves that pass through the planet during earthquakes. Earth is distinctly layered and each layer has its own unique characteristics.

## CRUST

The earth's crust is between 3 and 44 miles thick, being thickest where there are land masses and thinnest beneath the oceans. It makes up less than 1% of the planet's total volume.

## MANTLE

This layer of iron- and magnesium-rich silicate rock is hot enough (between 930° and 7,200°F) that it flows very slowly, causing earthquakes as the surface plates shift atop it. The mantle composes 84% of earth's volume.

## OUTER + CENTRAL CORE

The core has two parts: The outer core is primarily molten iron. The central core – an alloy of iron and nickel – is under so much pressure that it has crystallized into a solid even though it is hotter than the surface of the sun.

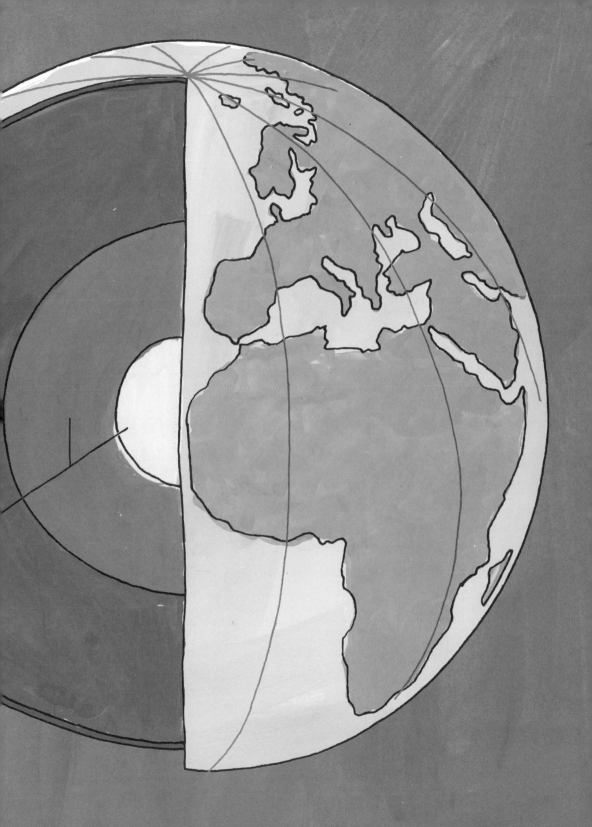

# Minerals

Minerals are naturally occurring solid substances consisting of inorganic materials. There are more than 4,000 identified minerals, with more being discovered every year.

RHODOCHROSITE

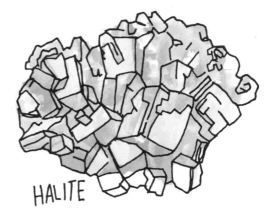

HALITE

TURQUOISE

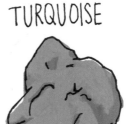

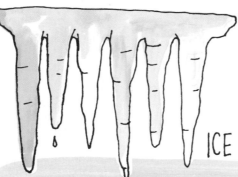

ICE

Liquid water is not a mineral, but naturally formed ice is one of the most common minerals on Earth.

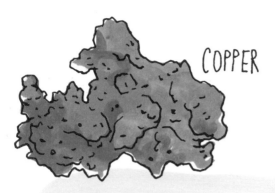

COPPER

GYPSUM
DESERT
ROSE

Minerals form through crystallization:
- through evaporation of a solution
  (like salt water evaporating into salt)

- through cooling (natural water
  freezing, magma solidifying)

- through changes in surrounding
  pressure and temperature
  (often found at faults and
    other tectonically active zones)

JEREMEJEVITE

QUARTZ

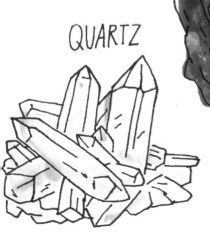

HEMATITE

AZURITE -
MALACHITE

# The Rock Cycle

Dynamic transitions take place among different types of rocks over long periods of time.

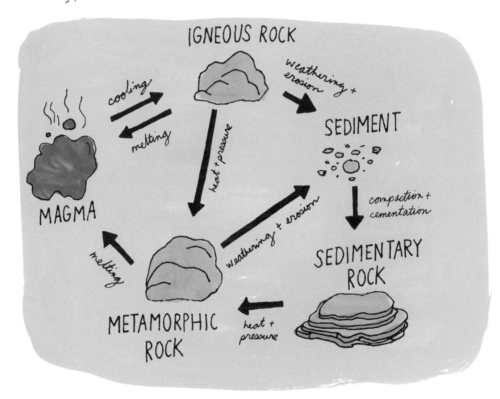

Rocks are altered or destroyed by natural forces: heat, pressure, friction, and weathering.

Based on how they are formed, rocks are classified into types:

## Igneous

Magma is molten rock beneath the surface of the earth. When magma cools and solidifies at or near the surface, it creates igneous rock.

GRANITE   BASALT   OBSIDIAN

## Sedimentary

As bits of minerals settle into layers over thousands of years, the weight of water and the layers of sediment above press down and cement the minerals into sedimentary rock.

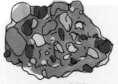

CONGLOMERATE   MUDSTONE   LIMESTONE

## Metamorphic

When sedimentary or igneous rocks are subjected to extreme pressure and heat, their mineral structures transform, resulting in metamorphic rock.

GNEISS   SCHIST   SLATE

# Fossils

The chances of an organism's being preserved as a fossil are very small. For a fossil to form, the organism must be covered in sediment shortly after its death. Then, water with high mineral content enters the small pores and cavities of the organism. With time and pressure, the minerals in the water are deposited into the structure of the organism and solidify, leaving behind a three-dimensional fossil.

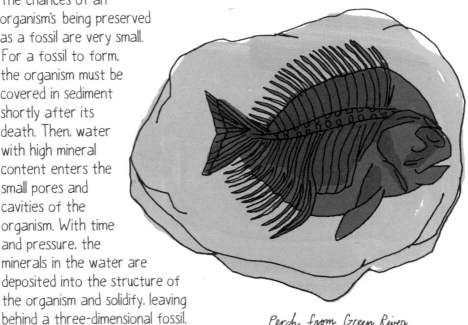

Perch from Green River Formation of southwest Wyoming

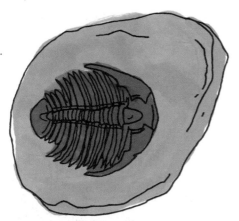

Trilobite from Marjum Formation in Millard County, Utah

Not all parts of a creature become fossilized. Soft parts of the anatomy, like skin and internal organs, often decompose before fossilization.

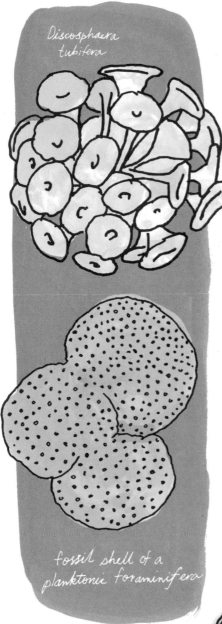

Discosphaera tubifera

fossil shell of a planktonic foraminifera

[ MAGNIFIED MILLIONS OF TIMES! ]

# Microfossils

The fossils displayed in museums are macrofossils, that is, larger than 1 millimeter and visible to the naked eye. Vastly more numerous are microfossils, the tiny preserved remains of bacteria, diatoms, fungi, protists, invertebrate shells or skeletons, pollen, and bits of bones and teeth of vertebrates. Microfossils usually occur in large numbers in all kinds of sedimentary rocks.

The Egyptian pyramids were built with sedimentary rocks made up of shells of foraminifera, a major microfossil group.

Radiolaria

21

# ❧ LANDFORMS ❧

## Canyon

a deep river valley with very steep sides, carved into the land by rivers over long periods of time

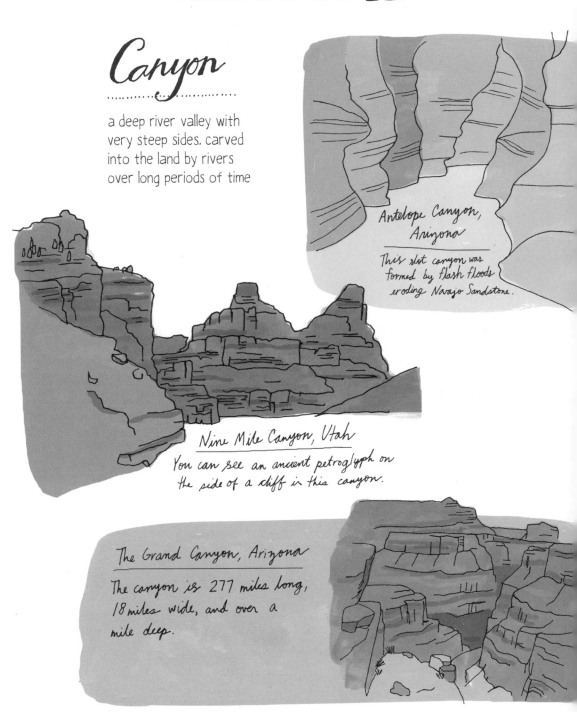

Antelope Canyon, Arizona

This slot canyon was formed by flash floods eroding Navajo Sandstone.

Nine Mile Canyon, Utah

You can see an ancient petroglyph on the side of a cliff in this canyon.

The Grand Canyon, Arizona

The canyon is 277 miles long, 18 miles wide, and over a mile deep.

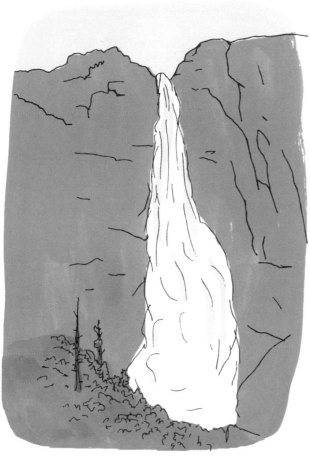

# Cataract
...................................

a large and powerful waterfall

Yosemite Falls,
California

This is the highest
waterfall in
North America.

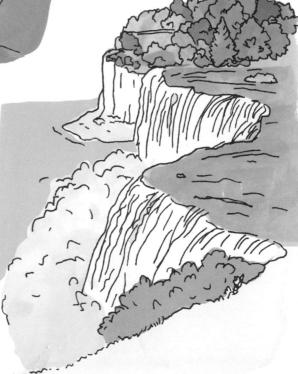

Niagara Falls,
border of Ontario,
Canada, and
New York

It has the
highest flow rate
of any waterfall
in the world.

# Delta

a low, triangular formation at the mouth of a river where silt, sand, and small rocks are deposited where the river meets a larger body of water

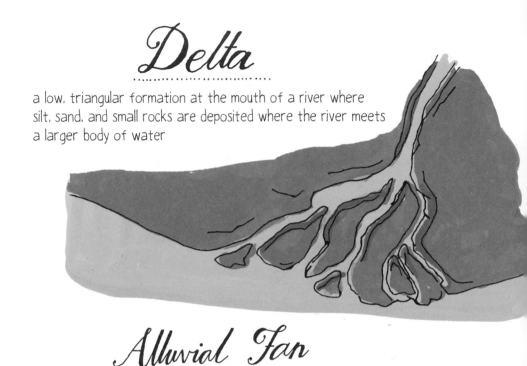

# Alluvial Fan

made of large amounts of sediment deposited by streams and rivers in a fan shape, most frequently where a canyon drains from mountains and spreads out over a flat plain

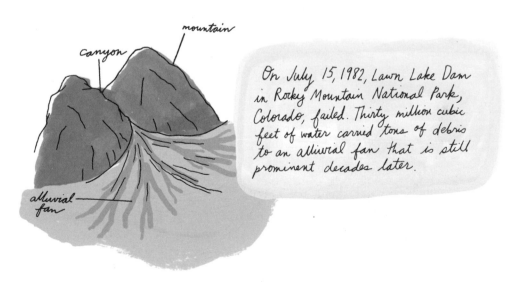

mountain

canyon

alluvial fan

On July 15, 1982, Lawn Lake Dam in Rocky Mountain National Park, Colorado, failed. Thirty million cubic feet of water carried tons of debris to an alluvial fan that is still prominent decades later.

# Archipelago

a cluster or chain of islands found in a sea or ocean

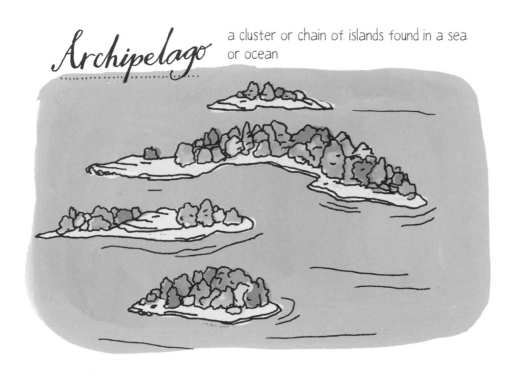

# Isthmus

a narrow bridge of land connecting two larger land masses across a body of water

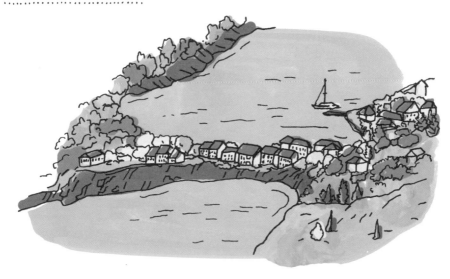

## Arête

a thin ridge of rock left between the erosion paths of two parallel glaciers

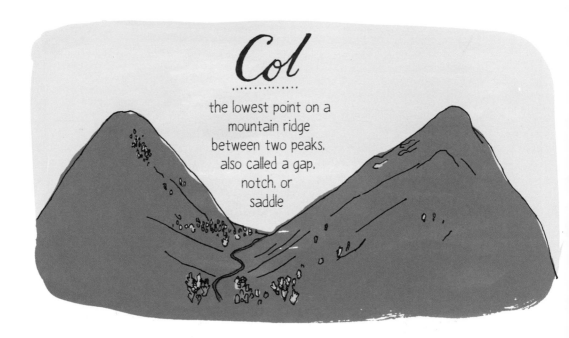

## Col

the lowest point on a mountain ridge between two peaks, also called a gap, notch, or saddle

## Plateau

a massive area of flat terrain that is higher than the surrounding area

## Mesa

a smaller area of elevated arid land with a flat top and sides that are usually steep cliffs

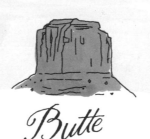

## Butte

an even smaller area of raised land with steep sides. Most buttes were once larger mesas.

# ❊ MOUNTAINS ❊

Mountains are formed over long periods of time by plate tectonics, the process by which large pieces of the earth's crust shift, collide, crumple, and slide. With their varying climate zones, altitude, and steepness, mountains are home to unique flora and fauna.

There are three primary types of mountain: fold, block, and volcanic.

## Fold Mountains

As the earth's plates collide or ride one over another, the crust tends to buckle and fold upward. Most of the Appalachian and Rocky Mountain ranges are associated with this type of movement.

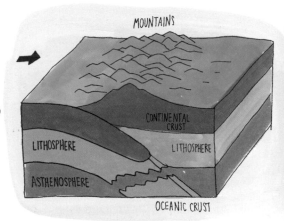

## Block Mountains

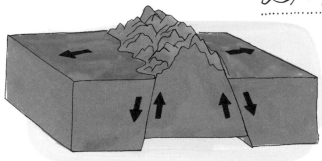

Block, or fault-block, mountains, are distinguished by enormous sheer rock faces like those found in the Sierra Nevada range in California. Block mountains form when tectonic pressure forces a huge rock mass to break apart. This line of separation is called a fault. The rocks rise on one side of the fault and sink down on the other side, creating dramatic cliffs.

# Volcanic Mountains

Volcanic mountains form where two plates of the earth's crust move together or apart, rather than sliding past each other. The magma that volcanic mountains emit often comes from crust material that melts as it is pushed down into the hot mantle below an advancing tectonic plate.

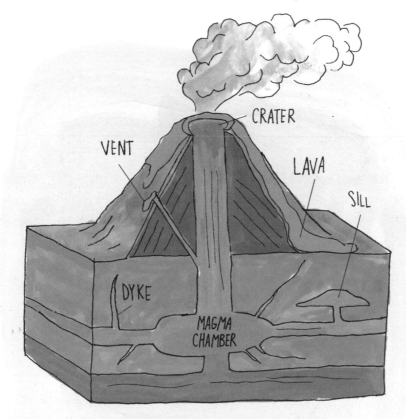

There are about 1,500 volcanoes that are known to have been active in the last 10,000 years.

# NORTH AMERICAN LANDSCAPES

## Deserts

Although deserts typically receive less than 10 inches of rain per year, the harsh dry terrain is often rich with life.

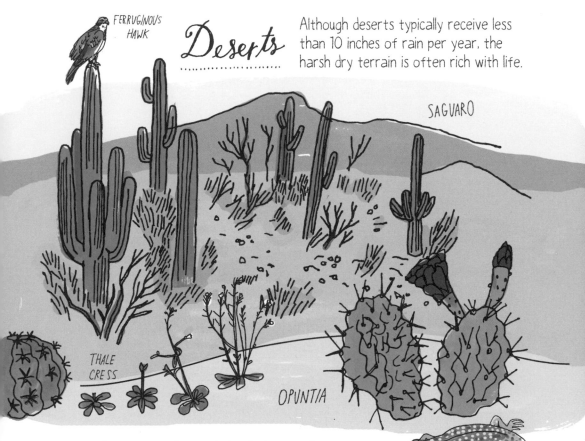

FERRUGINOUS HAWK

SAGUARO

THALE CRESS

OPUNTIA

NORTHERN DESERT IGUANA

Desert animals avoid the desiccating heat of day by sleeping in the shade or burrowing underground. Some even remain in a state of dormancy during very dry spells.

Desert plants can store water for long periods and often have protective spines or needles to keep thirsty animals at bay. Some species germinate and bloom as if in fast-forward, living out their entire lives in the few short weeks after a rare rainfall.

PLAINS BISON

# Grasslands

Wide-open treeless areas dominated by grasses, sedges, and rushes occur naturally in most regions of the earth. Grasslands have the deepest soil base of any landscape. Rich soils in an undisturbed grassland can extend as deep as 20 feet.

PRAIRIE DOG

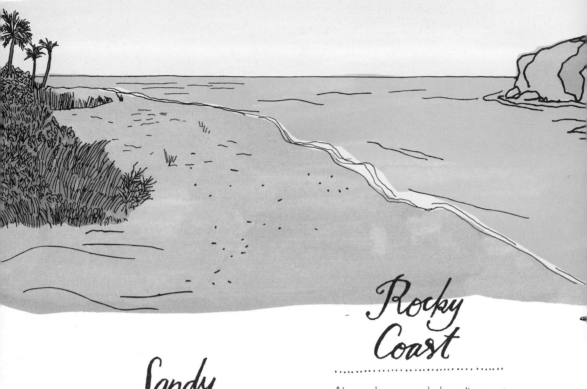

## Sandy Shore

Where land meets the open ocean, the eternal beating of waves breaks down rocks and shells into fine sand. Wind and waves constantly move and reshape the shoreline. Salt-tolerant beach grasses, rushes, heathers, and roses hold the dunes and sandy shoreline together.

## Rocky Coast

Along the rugged shorelines of inlets, islands, and promontories, the sea's power carves arches and caves into the rocky cliffs. Well above the surface, seabirds nest on protected crags, wind-dwarfed conifers cling to the rocks, and blue-green algae and lichens live amidst the ocean spray. In areas submerged for part of the day, tawny rockweeds and mussels thrive. Limpets, barnacles, and kelp extend from just below the surface out to sea.

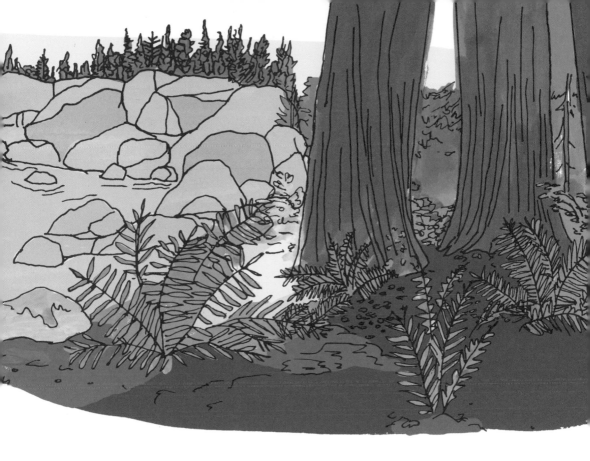

# Moist Coastal Forest

Large ferns, thick blankets of moss, and massive trees give the moist coastal forest the impression of a timeless land. Rain and fog provide consistent moisture, and the mild oceanic climate allows plants to reach great size since they can grow much of the year.

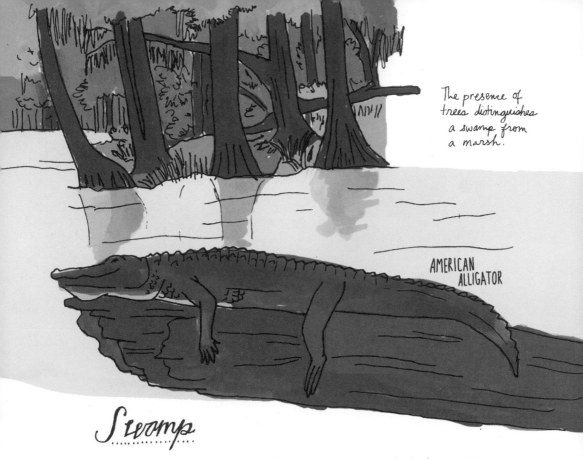

The presence of trees distinguishes a swamp from a marsh.

AMERICAN ALLIGATOR

# Swamp

In these forested wetlands, birdlife is often spectacularly diverse. Many amphibians, fish, and mammals also thrive in these lush environments. Duckweed and water lilies spread across the surface of the slow-moving water. Alligators, turtles, and venomous cottonmouth snakes can be found basking in warm southern swamps.

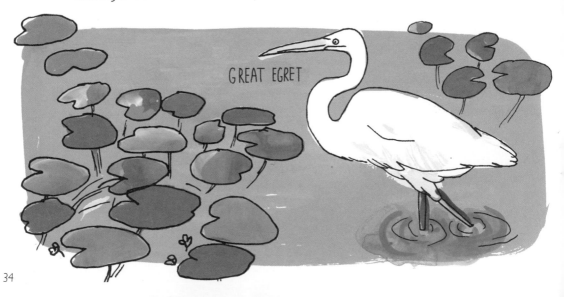

GREAT EGRET

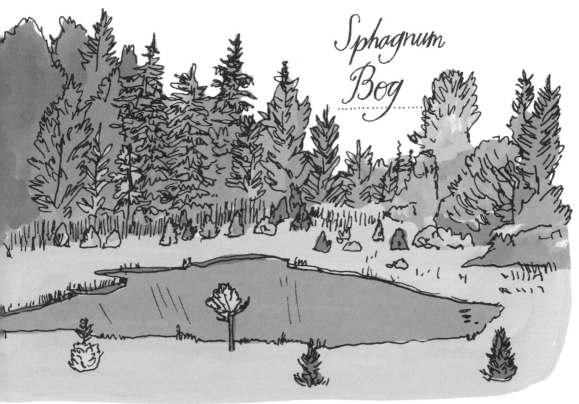

# Sphagnum Bog

*Most bogs transition from open water to forested land over many years.*

Sphagnum mosses are northern wetland plants that help create unique bog habitats in glacial depressions. The mosses decay extremely slowly, accumulating into thick layers of peat. Sedges, orchids, labrador tea, and even carnivorous plants are found in the cold microclimate of the sphagnum bog. Wetlands deplete available oxygen and peat acidifies its surroundings, so fish and many other aquatic organisms are generally scarce.

*Bog lemmings have bright green droppings!*

# Field Succession

If a piece of land previously used for agriculture or logging is left alone, it slowly begins to revert to its wild state. Succession is the process by which a field transitions to woodland.

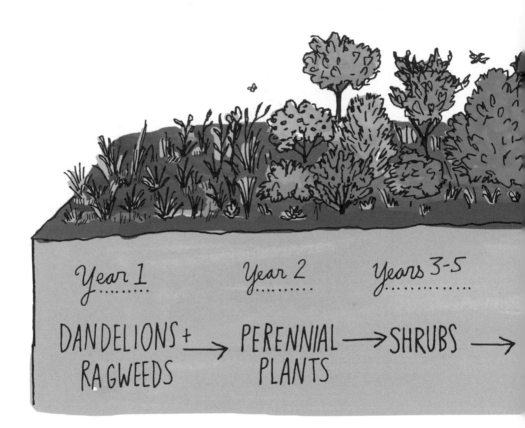

Year 1     Year 2     Years 3-5

DANDELIONS + RAGWEEDS → PERENNIAL PLANTS → SHRUBS →

In temperate zones, early species include hardy, sun-tolerant plants like dandelions, ragweed, and lamb's-quarters. Gradually, plants such as thistles, Queen Anne's lace, and milkweed take hold.

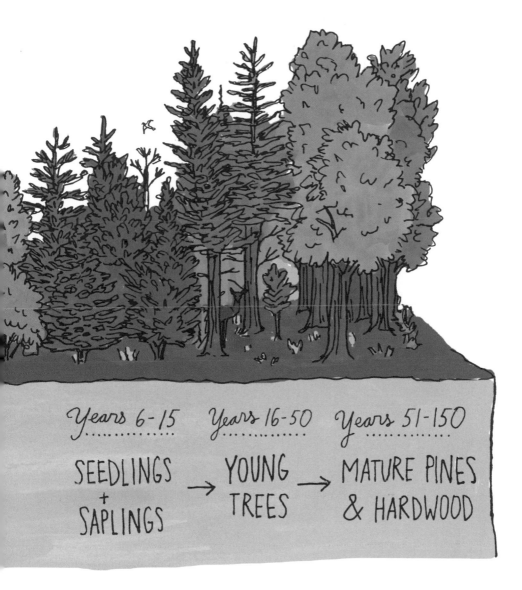

Years 6-15 → Years 16-50 → Years 51-150

SEEDLINGS + SAPLINGS → YOUNG TREES → MATURE PINES & HARDWOOD

As the vegetation matures, animals and insects are attracted by the increased cover and forage. Woodchucks, cottontail rabbits, foxes, and deer can be found, as well as butterflies, sparrows, meadowlark, and quail. Birds and squirrels deposit the seeds of trees such as black cherry, oak, mulberry, and staghorn sumac.

# Loose Landscape Painting

## TOOLS

- Pigment of your choice: watercolor, gouache (my favorite — it's what this book was painted with), crayon, colored pencil
- Thick paper or small canvas
- Medium to large paintbrush

## INSTRUCTIONS

Find an intriguing landscape and sit in a quiet, comfortable spot with an ideal view of your subject. Squint your eyes to see the scene out of focus. Look at the area as chunks of color without any close details.

Block in the color in large strokes. Think about using colors that complement each other even if they aren't exactly accurate. Keep adding color shapes until the entire page is full. Try not to leave white paper. If you want to have white, paint it rather than leaving the paper blank.

## TIPS

Hold your paintbrush near the tip, not the brush, so it's a bit looser in your hand and harder to control. Do lots of paintings of the same scene, switching the colors slightly to see how much it changes the image.

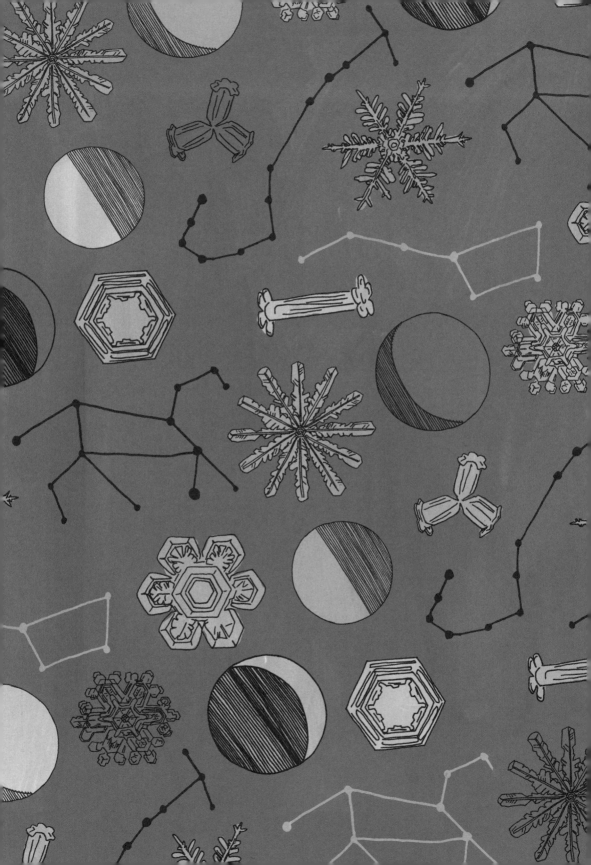

CHAPTER 2

What's' Up?

# UP IN THE ATMOSPHERE

The atmosphere encompasses all of the layers of gaseous masses that surround the earth.

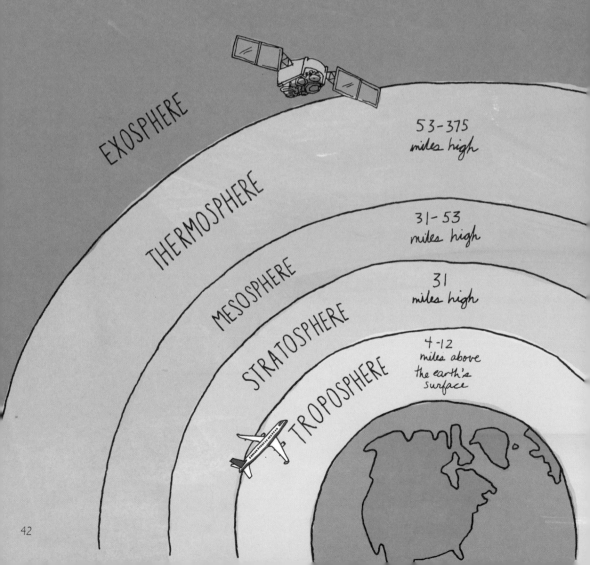

EXOSPHERE

53-375 miles high

THERMOSPHERE

31-53 miles high

MESOSPHERE

31 miles high

STRATOSPHERE

TROPOSPHERE

4-12 miles above the earth's surface

The TROPOSPHERE is the lowest atmospheric level and almost all weather occurs in this region. The troposphere begins at the earth's surface and extends from 4 to 12 miles high.

The STRATOSPHERE holds 19 percent of the atmosphere's gases but very little water vapor.

The gases, including oxygen molecules, continue to become less dense as one ascends the MESOSPHERE.

The THERMOSPHERE is also known as the upper atmosphere. Ultraviolet and x-ray radiation from the sun gets absorbed by the molecules in this layer, which results in a temperature increase.

In the EXOSPHERE, atoms and molecules escape into space and satellites orbit the earth.

# Predicting Weather

Here are some ways to predict weather so you're not caught off guard on a hike:

## CLOUD FORMATION
Certain types of clouds are good indicators of precipitation or storms.

## MORNING DEW
Heavy dew means there aren't strong winds to dry it off. That usually forecasts fair weather.

## FLIGHT PATTERNS
Birds fly lower to the ground when a storm is coming because the air pressure hurts their ears.

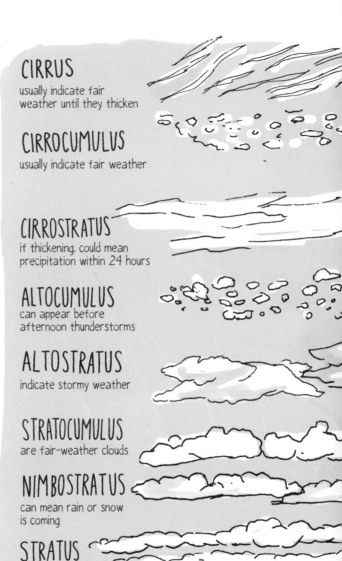

## CIRRUS
usually indicate fair weather until they thicken

## CIRROCUMULUS
usually indicate fair weather

## CIRROSTRATUS
if thickening, could mean precipitation within 24 hours

## ALTOCUMULUS
can appear before afternoon thunderstorms

## ALTOSTRATUS
indicate stormy weather

## STRATOCUMULUS
are fair-weather clouds

## NIMBOSTRATUS
can mean rain or snow is coming

## STRATUS
are low-lying clouds that create fog and drizzle

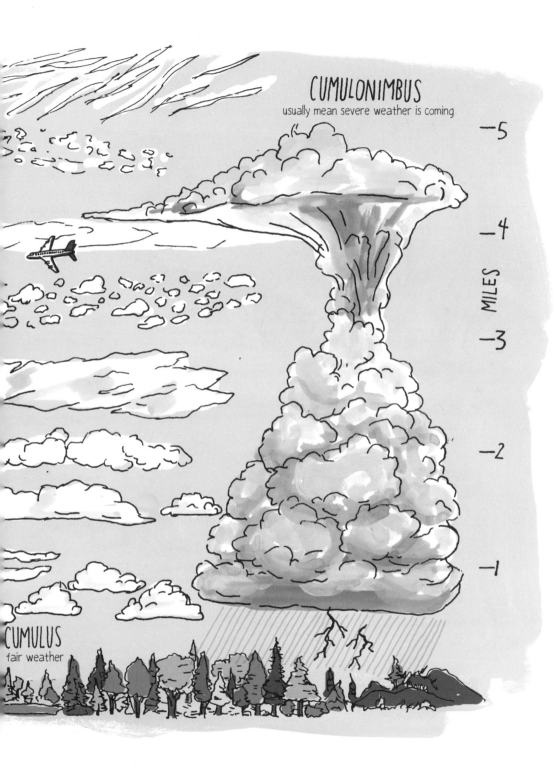

CUMULONIMBUS
usually mean severe weather is coming

-5

-4

MILES

-3

-2

-1

CUMULUS
fair weather

# The Water Cycle

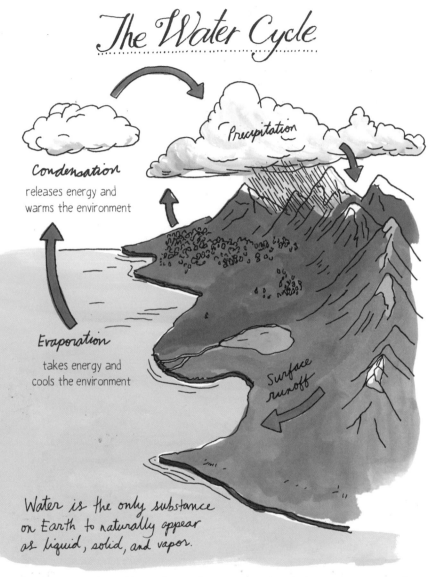

Precipitation

Condensation

releases energy and
warms the environment

Evaporation

takes energy and
cools the environment

Surface
runoff

Water is the only substance
on Earth to naturally appear
as liquid, solid, and vapor.

In the natural world, water is always moving and changing its form. It travels from streams to rivers to oceans, from lakes and oceans to the atmosphere, and from the atmosphere back to land. This cycle slowly purifies water and replenishes the land with fresh water.

# Fog vs. Mist

Fog is a stratus cloud formation located close to the surface of the earth. Mist is made of tiny water droplets suspended in the air. Both can form when there is a significant temperature difference between the air and the ground. Bodies of water or moist ground in the immediate area provide the water vapor that becomes mist or fog.

The main difference is that fog reduces visibility to less than 1 kilometer; you can see farther in mist.

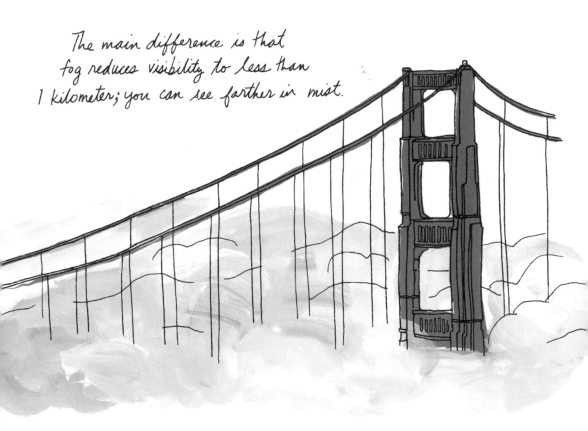

# Thunderstorm

Storms develop when masses of very cold air collide with masses of very warm air. As the warm air rises, surface air pressure drops, creating a vacuum effect. Cold air rushes in, forcing more warm air upward in a turbulent cycle that can produce strong winds, rain, and hail.

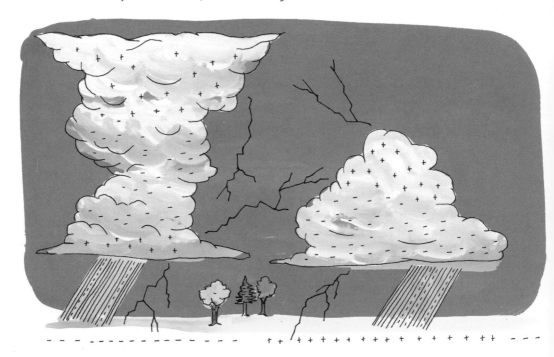

# Lightning

The air is full of ions (atoms or molecules with an electrical charge). In a thundercloud, positive ions are grouped near the top of the cloud and negative ones at the bottom. When the difference in voltage becomes great enough, a bolt of lightning balances out the charge. Lightning can bridge the top and bottom of a cloud or strike from the cloud to the ground. Claps of thunder result from sound waves created by the lightning.

# Tornado

The collision of hot and cold air can produce mammoth rotating thunderstorms called supercells. A tornado is a violently rotating column of air that stretches between the cumulonimbus clouds of a supercell and the ground.

Tornadoes are classified by wind speed and destructive power on the Enhanced Fujita Scale between EF0 and EF5.

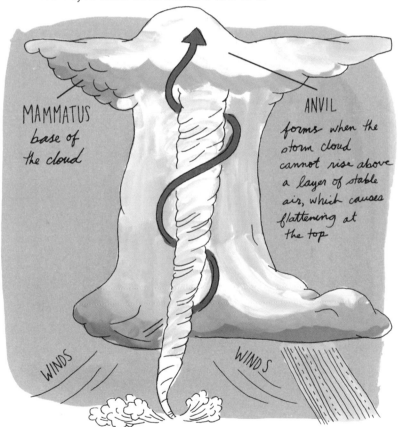

MAMMATUS
base of
the cloud

ANVIL
forms when the
storm cloud
cannot rise above
a layer of stable
air, which causes
flattening at
the top

WINDS

WINDS

Tornado Alley in the central United States has the highest occurrence of tornadoes in the world.

## WHY ARE ALL SNOWFLAKES DIFFERENT?

A snowflake's shape is determined by temperature and humidity. At low temperatures inside a cloud, water vapor crystallizes directly into solid ice through a process called deposition. These tiny ice crystals keep growing until they are heavy enough to fall from the cloud as snowflakes.

As a crystal grows, the molecules do not stack together with perfect regularity. Each falling snowflake travels a unique path through many different microclimates, resulting in a different shaped arrangement of crystals.

CAPPED COLUMN

BULLET ROSETTES

NEEDLE CLUSTERS

HOLLOWED COLUMNS

# SOME SNOWFLAKE SHAPES

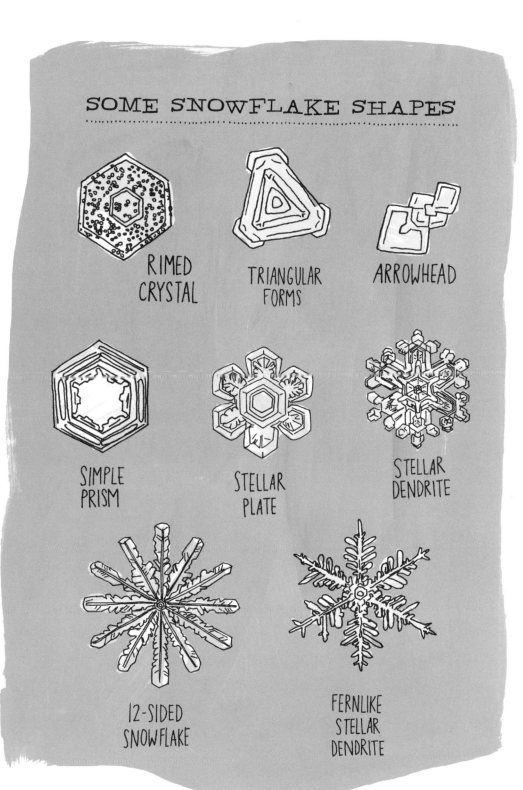

RIMED
CRYSTAL

TRIANGULAR
FORMS

ARROWHEAD

SIMPLE
PRISM

STELLAR
PLATE

STELLAR
DENDRITE

12-SIDED
SNOWFLAKE

FERNLIKE
STELLAR
DENDRITE

# RAINBOWS

The familiar multicolored arc of a rainbow is one of nature's most striking phenomena. Rainbows are formed by light refracting and reflecting through tiny water droplets in the air. Light from the sun may look white or yellow, but it is actually a combination of many colors.

*A rainbow always appears directly opposite the sun, but the observer's location determines its apparent position.*

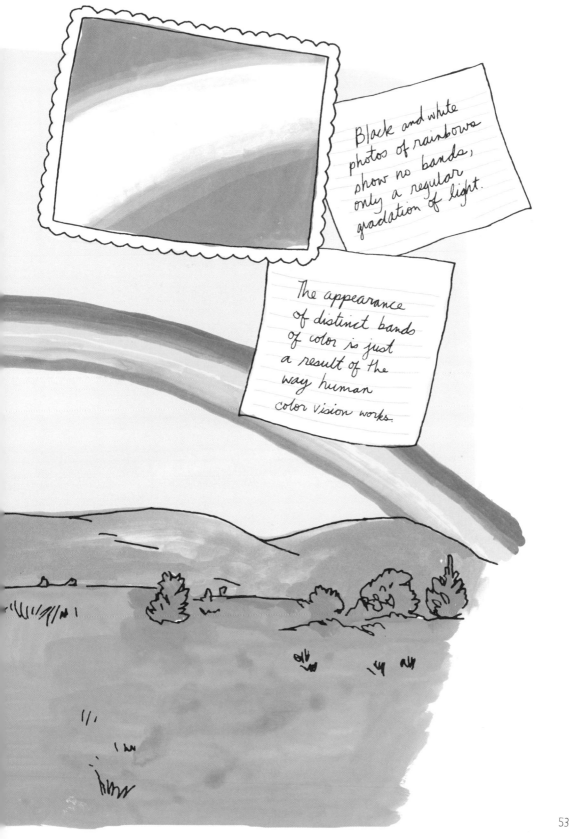

Black and white photos of rainbows show no bands, only a regular gradation of light.

The appearance of distinct bands of color is just a result of the way human color vision works.

# SUNSETS

Sunlight is made up of many different wavelengths and colors of light. When sunlight strikes particles in the atmosphere (such as water and air molecules, dust, pollen, or pollution), certain wavelengths are deflected and refracted more than others.

Because of the indirect angle of the sunlight striking the earth at sunset, the light has to travel through more atmospheric particles, so more of it is scattered. Blue and green wavelengths are largely filtered out, leaving the longer-wavelength orange and red hues.

The colors of sunsets are often more dramatic than sunrise colors because evening air is warmer and holds more particles aloft than morning air.

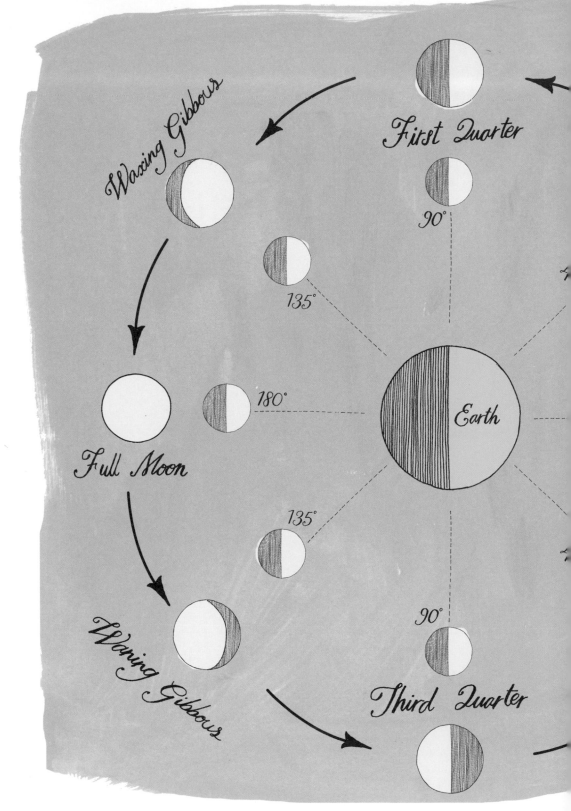

Waxing Gibbous

First Quarter

90°

135°

180°

Full Moon

Earth

135°

Waning Gibbous

90°

Third Quarter

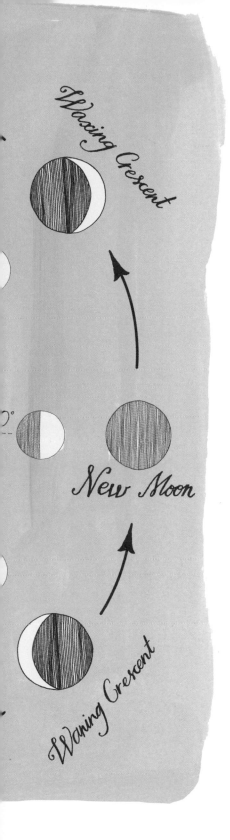

Waxing Crescent

New Moon

Waning Crescent

# Phases of the Moon

Sunlight

# CONSTELLATIONS

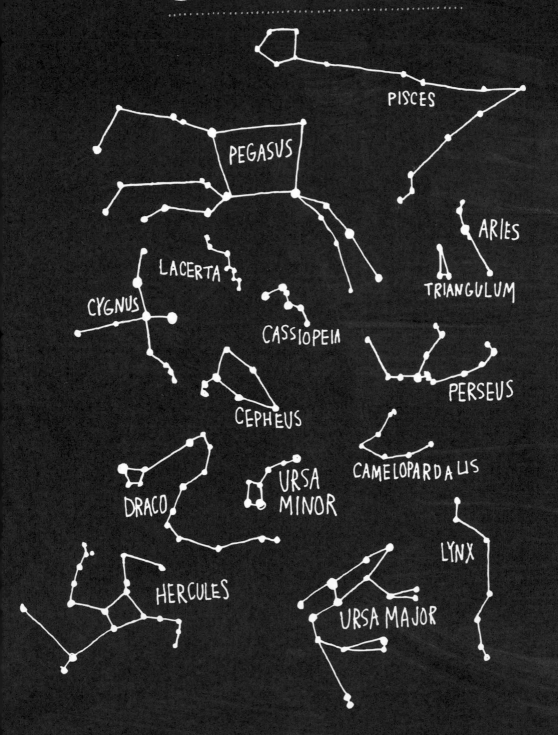

PISCES

PEGASUS

ARIES

LACERTA

TRIANGULUM

CYGNUS

CASSIOPEIA

PERSEUS

CEPHEUS

CAMELOPARDALIS

DRACO

URSA MINOR

LYNX

HERCULES

URSA MAJOR

For thousands of years, humans have sought and found meaning in the patterns of the stars. Constellations, or asterisms, are images formed by groups of prominent stars in the night sky. Though the stars of a single constellation appear to be close to each other, they may in fact be many light years apart.

The images and meanings ascribed to constellations have varied between cultures and eras, but the International Astronomical Union currently recognizes 88 constellations in the northern and southern skies. Many constellation names we use today are Latin and from the time of the Roman empire, though the particular meanings and images are often much older than that.

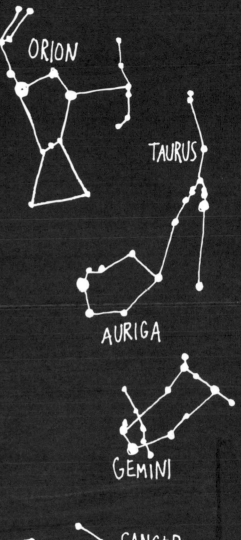

ORION

TAURUS

AURIGA

GEMINI

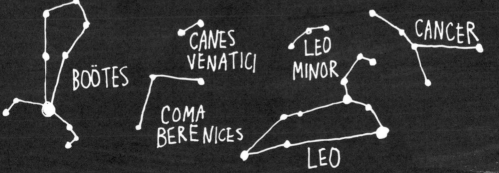

BOÖTES

CANES VENATICI

COMA BERENICES

LEO MINOR

LEO

CANCER

CHAPTER 3

Come Close

# ANATOMY OF A FLOWER

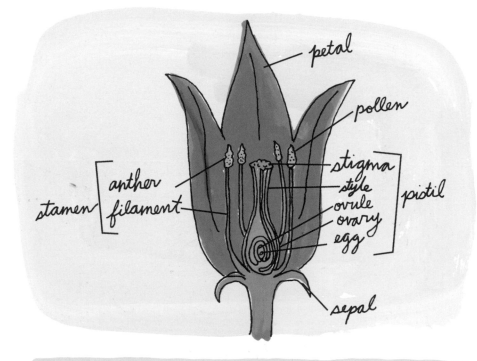

anther - male reproductive cell that contains pollen

filament - supports the anther

sepal - modified leaf beneath the flower

stamen - includes the male parts of the flower

pistil - includes the female parts of the flower

ovary - female reproductive organ

ovule - reproductive cell; forms the seed when fertilized with pollen

stigma - structure atop the ovary that receives pollen

style - stalk that connects the stigma and the ovary

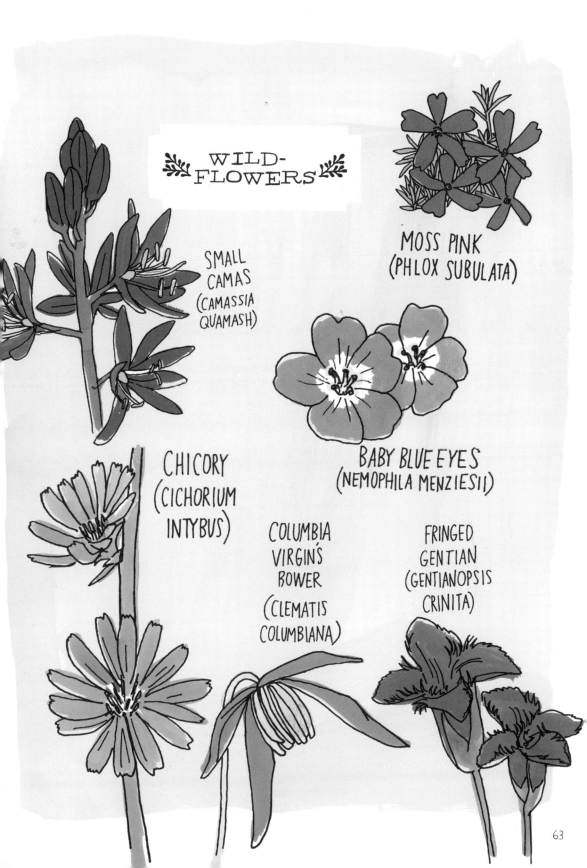

WILD-FLOWERS

MOSS PINK
(PHLOX SUBULATA)

SMALL
CAMAS
(CAMASSIA
QUAMASH)

BABY BLUE EYES
(NEMOPHILA MENZIESII)

CHICORY
(CICHORIUM
INTYBUS)

COLUMBIA
VIRGIN'S
BOWER
(CLEMATIS
COLUMBIANA)

FRINGED
GENTIAN
(GENTIANOPSIS
CRINITA)

63

QUEEN ANNE'S LACE (DAUCUS CAROTA)

PHILADELPHIA FLEABANE (ERIGERON PHILADELPHICUS)

SPOTTED WINTERGREEN (CHIMAPHILA MACULATA)

SPECTACLE POD (DIMORPHOCARPA WISLIZENI)

SOUTHWESTERN THORNAPPLE (DATURA WRIGHTII)

LONG-LEAVED PHLOX (PHLOX LONGIFOLIA)

BLOODROOT (SANGUINARIA CANADENSIS)

NODDING WILD ONION (ALLIUM CERNUUM)

WHITE HEATHER (CALLUNA VULGARIS)

BULL THISTLE (CIRSIUM VULGARE)

SKYROCKET (IPOMOPSIS AGGREGATA)

NORTHERN PITCHER PLANT (SARRACENIA PURPUREA)

TRILLIUM (TRILLIUM ERECTUM)

WOODS ROSE (ROSA WOODSII)

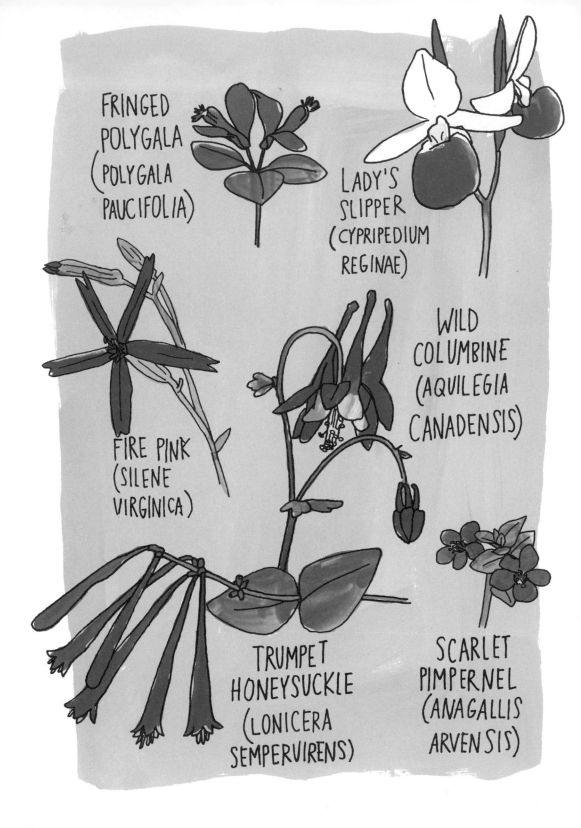

FRINGED
POLYGALA
(POLYGALA
PAUCIFOLIA)

LADY'S
SLIPPER
(CYPRIPEDIUM
REGINAE)

FIRE PINK
(SILENE
VIRGINICA)

WILD
COLUMBINE
(AQUILEGIA
CANADENSIS)

TRUMPET
HONEYSUCKLE
(LONICERA
SEMPERVIRENS)

SCARLET
PIMPERNEL
(ANAGALLIS
ARVENSIS)

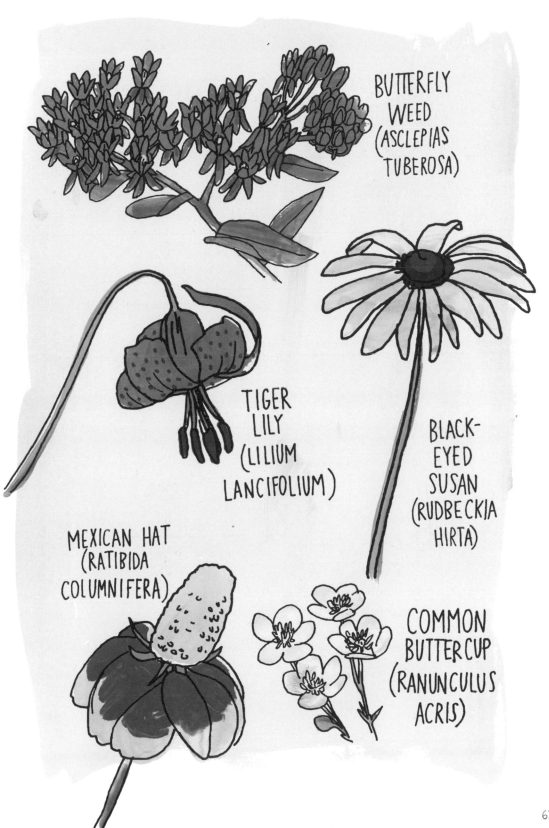

BUTTERFLY WEED (ASCLEPIAS TUBEROSA)

TIGER LILY (LILIUM LANCIFOLIUM)

BLACK-EYED SUSAN (RUDBECKIA HIRTA)

MEXICAN HAT (RATIBIDA COLUMNIFERA)

COMMON BUTTERCUP (RANUNCULUS ACRIS)

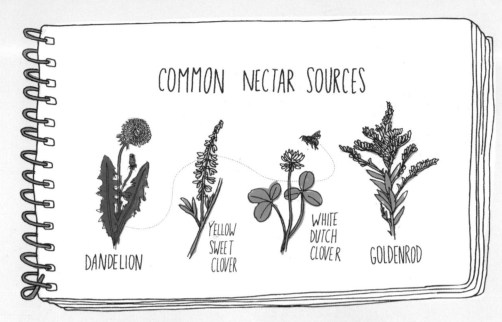

# COMMON NECTAR SOURCES

DANDELION

YELLOW SWEET CLOVER

WHITE DUTCH CLOVER

GOLDENROD

## HONEY

North America has some 4,000 species of native bees, but our familiar honey bee came over from Europe with the settlers.

## LEAF CUTTER

## CARPENTER

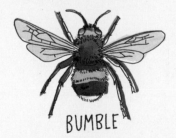

## BUMBLE

## SWEAT

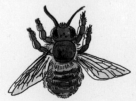

## MASON

# ANATOMY OF A BEE

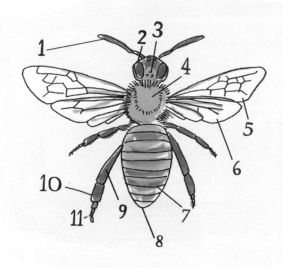

1. **antenna** - contains thousands of tiny sensors that detect smell
2. **compound eye** - for general distance sight
3. **ocellus** - three simple eyes used for low light conditions in the hive
4. **thorax** - segment between head and abdomen where wings attach
5. **forewing**
6. **hindwing** — 2-part wings hook together in flight but separate at rest
7. **abdomen** - contains all the organs, wax glands, and stinger
8. **stinger** - only present on worker and queen bees
9. **femur**
10. **tibia** — three pairs of legs with six segments each;
11. **tarsal claw** used for walking and packing pollen

# BUTTERFLY FAMILIES OF NORTH AMERICA

**swallowtails** (FAMILY PAPILIONIDAE)

medium to large, tail-like appendages on hindwings, colorful

**brush-footed** (FAMILY NYMPHALIDAE)

largest family, two shorter legs used for tasting food

**whites + sulphurs** (FAMILY PIERIDAE)

mostly white or yellow wings with black or orange marks

**gossamer-winged** (FAMILY LYCAENIDAE)

sheer wings, smaller sized, includes hairstreaks, blues and copper

**metalmarks** (FAMILY RIODINIDAE)

small to medium, mostly tropical, metallic marks

TRUE BUTTERFLIES

**skippers** (FAMILY HESPERIIDAE)

wide thoraxes, small wings, hooked antennae, brown and gray with white and orange marks

# ANATOMY OF A BUTTERFLY

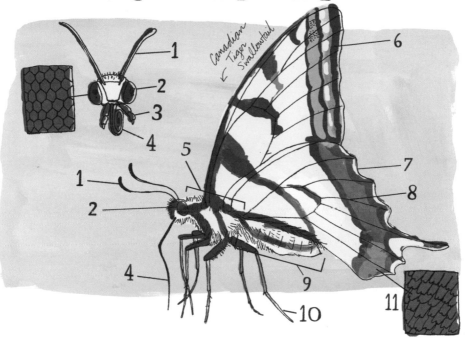

Canadian
← Tiger
Swallowtail

1. **antenna** - used as a form of radar and pheromone detection
2. **compound eye** - has up to 1,700 individual ommatidia (light receptors and lenses)
3. **palpus** - shields the eye from dust, covered in scent-detecting sensors
4. **proboscis** - like a long straw for feeding and drinking
5. **thorax** - three body segments that contain the flight muscles
6. **forewing** ⎤
7. **hindwing** ⎬— two pairs of overlapping wings that flap and sometimes glide
8. **wing veins** - vary between each genus of butterfly, used in classification
9. **abdomen** - contains the digestive system, respiratory equipment, heart, and sex organs
10. **legs** - butterflies have three pairs except in the Nymphalidae family
11. **scales** - wings are covered in tiny dust-like colored scales

# Metamorphosis

The life cycle of a butterfly has four stages: 1. egg, 2. larva (caterpillar), 3. pupa (chrysalis), 4. adult (butterfly).

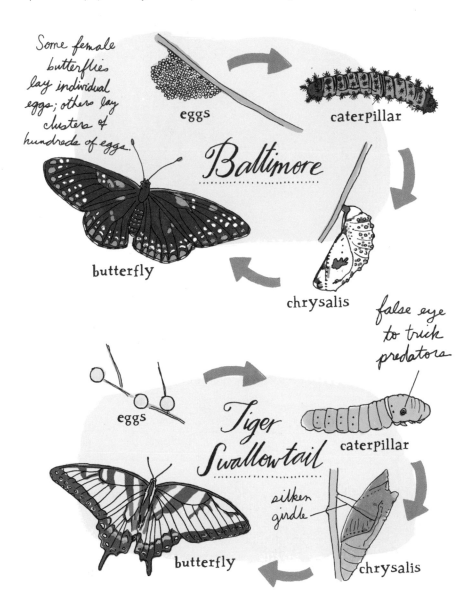

Some female butterflies lay individual eggs; others lay clusters of hundreds of eggs.

eggs

caterpillar

*Baltimore*

butterfly

chrysalis

false eye to trick predators

eggs

*Tiger Swallowtail*

caterpillar

silken girdle

butterfly

chrysalis

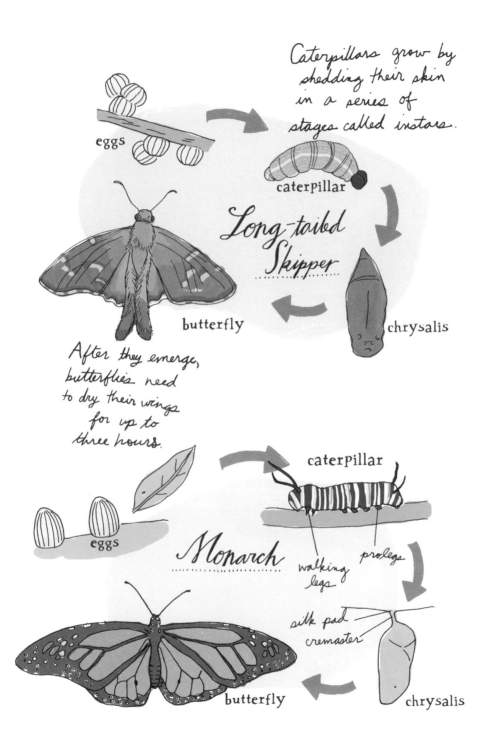

eggs

Caterpillars grow by shedding their skin in a series of stages called instars.

caterpillar

Long-tailed Skipper

butterfly

chrysalis

After they emerge, butterflies need to dry their wings for up to three hours.

caterpillar

eggs

Monarch

walking legs

prolegs

silk pad
cremaster

butterfly

chrysalis

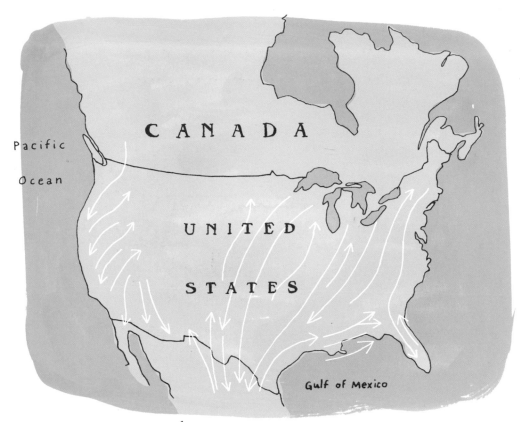

## Monarch Migration

Monarchs travel south in the winter and north in the summer, just like birds. Because of the butterflies' short lifespan, each migration consists of an entirely new generation.

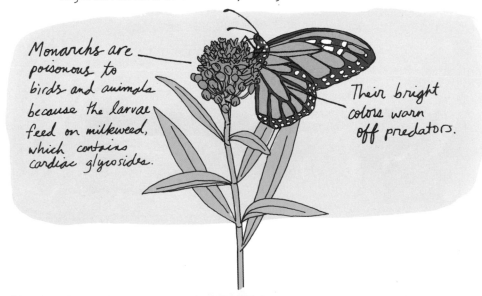

Monarchs are poisonous to birds and animals because the larvae feed on milkweed, which contains cardiac glycosides.

Their bright colors warn off predators.

# 🦋 PLANTS THAT 🦋
# ATTRACT BUTTERFLIES

## Anise Hyssop

attracts Red Admiral,
Monarch, Painted Lady,
Buckeye, Milbert's
Tortoiseshell, Pipevine
Swallowtail, Sulphur

## Butterfly Bush

attracts Monarch, Buckeye, Black Swallowtail,
Pipevine Swallowtail, Snout Butterfly, Great Spangled
Fritillary, Pearl Crescent, Red Admiral, Painted Lady,
Common Checkered Skipper, Nymphalidae

## New Jersey Tea

attracts Spring Azure, Coral
Hairstreak, Striped Hairstreak,
Edward's Hairstreak, Acadian
Hairstreak

## Cut-Leaf Coneflower

attracts Great Spangled
Fritillary, Pearl Crescent,
Viceroy, Monarch, Blues

## Pink Turtlehead

attracts Silver-Spotted
Skippers, Spicebush
Swallowtail, Tiger
Swallowtail

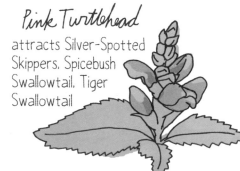

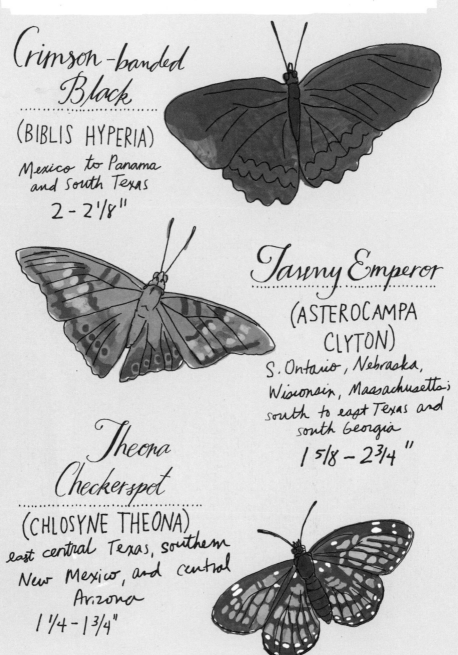

## Crimson-banded Black

(BIBLIS HYPERIA)

Mexico to Panama and south Texas

2 - 2 1/8"

## Tawny Emperor

(ASTEROCAMPA CLYTON)

S. Ontario, Nebraska, Wisconsin, Massachusetts; south to east Texas and south Georgia

1 5/8 - 2 3/4"

## Theona Checkerspot

(CHLOSYNE THEONA)

east central Texas, southern New Mexico, and central Arizona

1 1/4 - 1 3/4"

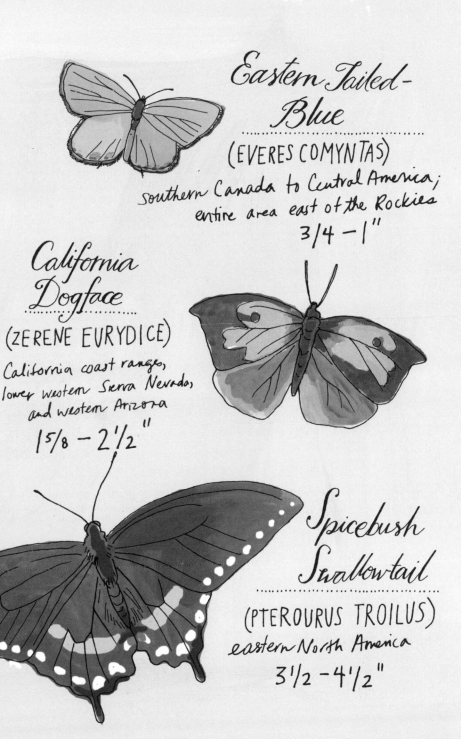

Eastern Tailed-
Blue
...................................
(EVERES COMYNTAS)
southern Canada to Central America;
entire area east of the Rockies
3/4 – 1"

California
Dogface
.............
(ZERENE EURYDICE)
California coast ranges,
lower western Sierra Nevada,
and western Arizona
1 5/8 – 2 1/2"

Spicebush
Swallowtail
...................................
(PTEROURUS TROILUS)
eastern North America
3 1/2 – 4 1/2"

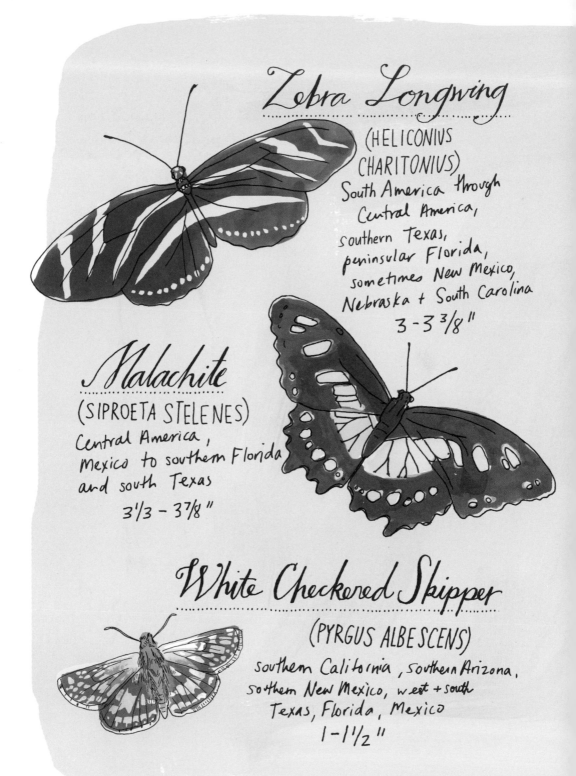

# Zebra Longwing

(HELICONIUS
CHARITONIUS)
South America through
Central America,
southern Texas,
peninsular Florida,
sometimes New Mexico,
Nebraska + South Carolina
3 - 3 3/8"

# Malachite

(SIPROETA STELENES)
Central America,
Mexico to southern Florida
and south Texas
3 1/3 - 3 7/8"

# White Checkered Skipper

(PYRGUS ALBESCENS)
southern California, southern Arizona,
southern New Mexico, west + south
Texas, Florida, Mexico
1 - 1 1/2"

# Buckeye

## (JUNONIA COENIA)

southern Manitoba, Ontario, Quebec, Nova Scotia – all over US except northwest
1 3/4 – 2 3/4"

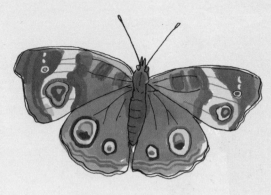

# Ruddy Daggerwing

Brazil through Central America; Mexico to south Florida. Rarely in Arizona, Colorado, Nebraska, Kansas, south Texas

## (MARPESIA PETREUS)
2 5/8 – 2 7/8"

# Sara Orangetip

## (ANTHOCHARIS SARA)

Alaska coast south to Baja, CA – west of Pacific Divide
1 – 1 1/2"

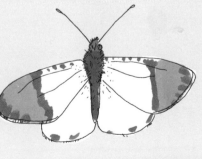

# ❧ COLORFUL MOTHS ❧

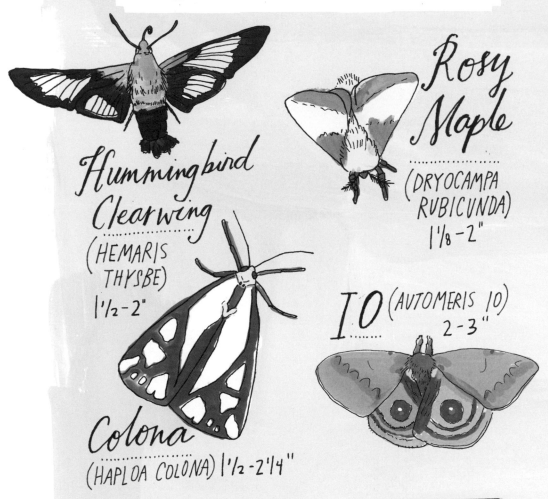

**Hummingbird Clearwing**
(HEMARIS THYSBE)
1½–2"

**Rosy Maple**
(DRYOCAMPA RUBICUNDA)
1⅛–2"

**Colona**
(HAPLOA COLONA) 1½–2¼"

**IO** (AUTOMERIS IO)
2–3"

| BUTTERFLY | VS. | MOTH |
|---|---|---|
| · active during the day | | · nocturnal |
| · uses sight to find mate | | · uses smell to find mate |
| · can't hear | | · has ears |
| · uses sun for warmth | | · flies for warmth |
| · makes hanging chrysalis | | · makes a cocoon |

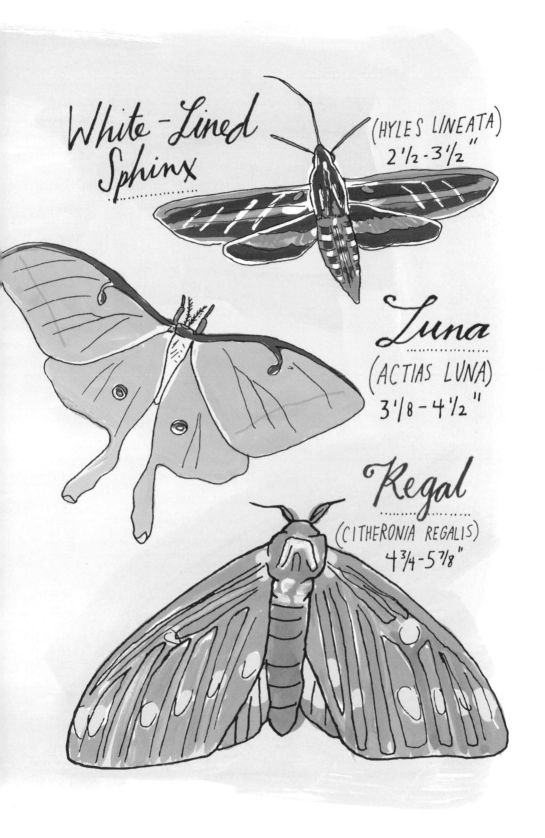

White-Lined Sphinx

(HYLES LINEATA)
2 1/2 - 3 1/2"

Luna

(ACTIAS LUNA)
3 1/8 - 4 1/2"

Regal

(CITHERONIA REGALIS)
4 3/4 - 5 7/8"

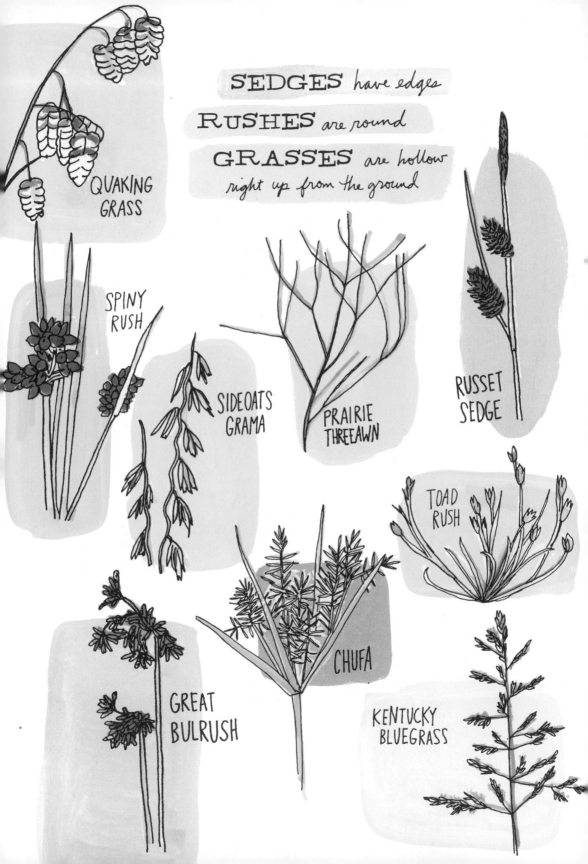

QUAKING GRASS

SEDGES *have edges*

RUSHES *are round*

GRASSES *are hollow right up from the ground*

SPINY RUSH

SIDEOATS GRAMA

PRAIRIE THREEAWN

RUSSET SEDGE

TOAD RUSH

GREAT BULRUSH

CHUFA

KENTUCKY BLUEGRASS

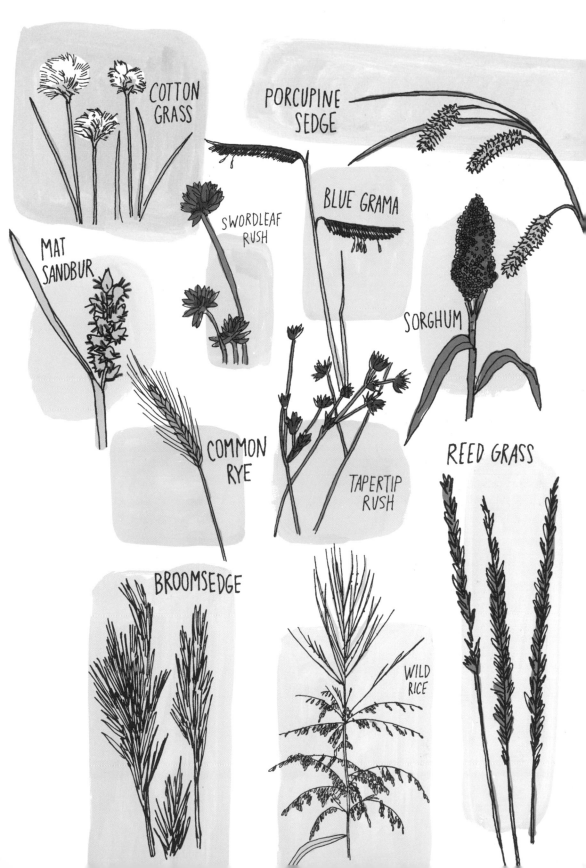

COTTON GRASS

PORCUPINE SEDGE

SWORDLEAF RUSH

BLUE GRAMA

MAT SANDBUR

SORGHUM

COMMON RYE

TAPERTIP RUSH

REED GRASS

BROOMSEDGE

WILD RICE

# GRAZING EDIBLES

## Young Chicory

Early spring shoots are good raw and the roots can be roasted for a coffee substitute.

## Miner's Lettuce

The nutritious, succulent leaves are delicious in raw salads.

## Violet

Young leaves are tasty and the pretty flowers can be candied or eaten raw.

## Young Dandelion

Use small leaves from the center of the whorl and serve raw or lightly steamed.

## Lamb's-Quarters

Packed with nutrients. Use this prolific wild plant just like spinach.

## Red Clover

High in protein, the leaves are good as a cooked green and the flowers make a nice tea.

## Mullein

Tea from the flowers and leaves is good for coughs and other lung problems.

## Plantain

Blanch the young leaves. Seeds can be ground into a nutritious meal and added to breads.

## Yarrow

Flowers make an aromatic tea. Leaves can be used in place of hops for beer making.

## Wood Sorrel

Flowers, fruits, and leaves are great as a sweet-sour trailside nibble.

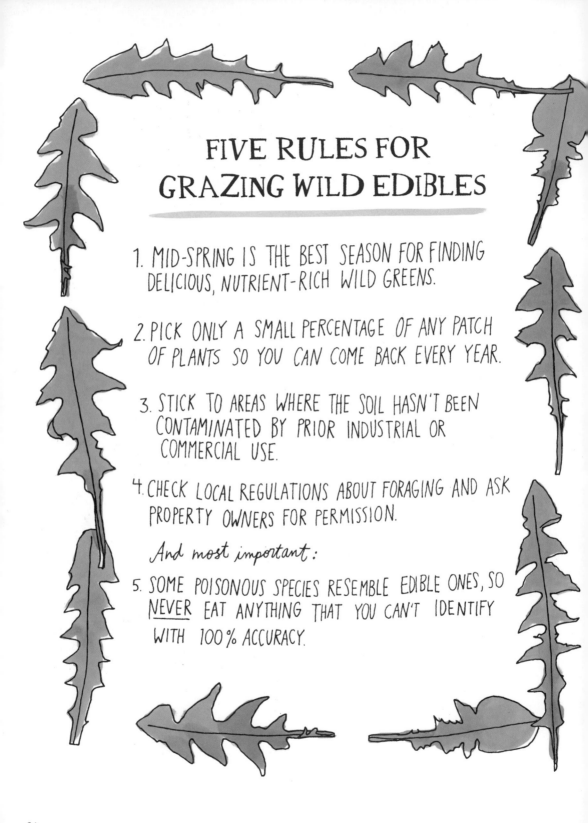

# FIVE RULES FOR GRAZING WILD EDIBLES

1. MID-SPRING IS THE BEST SEASON FOR FINDING DELICIOUS, NUTRIENT-RICH WILD GREENS.

2. PICK ONLY A SMALL PERCENTAGE OF ANY PATCH OF PLANTS SO YOU CAN COME BACK EVERY YEAR.

3. STICK TO AREAS WHERE THE SOIL HASN'T BEEN CONTAMINATED BY PRIOR INDUSTRIAL OR COMMERCIAL USE.

4. CHECK LOCAL REGULATIONS ABOUT FORAGING AND ASK PROPERTY OWNERS FOR PERMISSION.

*And most important:*

5. SOME POISONOUS SPECIES RESEMBLE EDIBLE ONES, SO NEVER EAT ANYTHING THAT YOU CAN'T IDENTIFY WITH 100% ACCURACY.

# Jenny Kendler's Gorgonzola-Stuffed Daylily Buds

DAYLILY BUDS (CHOOSE <u>UNOPENED</u> BUT MATURE BUDS, 2½-3½" LONG)

OLIVE OIL

GORGONZOLA CHEESE, OR A BLUE CHEESE OF YOUR CHOICE (CHOOSE A LOCAL CHEESE IF POSSIBLE)

FRESH CRACKED PEPPER

Preheat oven/toaster oven to 400°F. Arrange buds on a baking sheet that has been lightly coated with olive oil. Gently open each daylily bud and stuff with cheese, closing the petals back up as best as possible. Brush the stuffed lilies with a touch more olive oil, cracking fresh pepper generously over the tops. Bake until cheese begins to brown and bubble out. Serve hot, and enjoy this elegant, wild-harvested treat with friends.

# INCREDIBLE INSECTS AND BUGS ABOUNDING

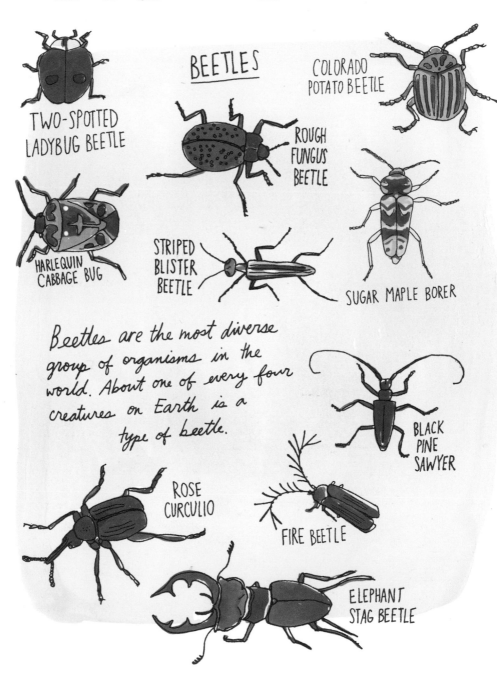

## BEETLES

TWO-SPOTTED LADYBUG BEETLE

COLORADO POTATO BEETLE

ROUGH FUNGUS BEETLE

HARLEQUIN CABBAGE BUG

STRIPED BLISTER BEETLE

SUGAR MAPLE BORER

Beetles are the most diverse group of organisms in the world. About one of every four creatures on Earth is a type of beetle.

BLACK PINE SAWYER

ROSE CURCULIO

FIRE BEETLE

ELEPHANT STAG BEETLE

### TACHINA FLY

The larvae are parasitoids that develop inside the body of other insects, eventually killing their hosts.

### ALUTACEA BIRD GRASSHOPPER

It can jump up to 20 times the length of its body — the equivalent of a 6-foot-tall man jumping 120 feet.

### SCARLET-AND-GREEN LEAFHOPPER

They are covered with tiny hairs and secrete a liquid over their bodies that acts as a water repellent and contains pheromones.

### PRAYING MANTIS

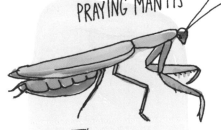

The female mantis sometimes bites the head off her mate during copulation.

### TRUE KATYDID

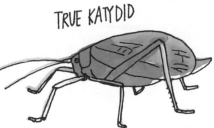

Katydids get their name from how their song sounds: "Katy did Katy didn't." Katydids lay their eggs in the fall on plants or in the soil, but they don't hatch until spring.

Some species of cicadas live underground, **17-YEAR CICADA**
feeding on tree roots and emerging in
great numbers in 13-17 year cycles. The
famously loud mating call made by
large groups of males can go over 120
decibels (breaking local noise laws in some
areas) and is thought to repel predatory birds.

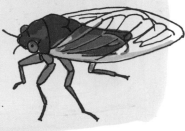

## GIANT DESERT SCORPION
The largest scorpion in North America —
attaining a growth of 5.5 inches in
length — feeds on lizards and snakes.

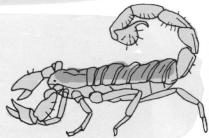

## PHANTOM CRANE FLY
They seem to disappear
when they fly out of
any source of light,
leaving only their white
spots visible.

## THORN-MIMIC TREEHOPPER
It camouflages itself
as a thorn when
sitting on a stem.

**SNOW FLEA** This type of springtail has a unique
jumping organ that folds beneath
the abdomen and can fling the insect
4 inches into the air.

# DRAGONFLIES

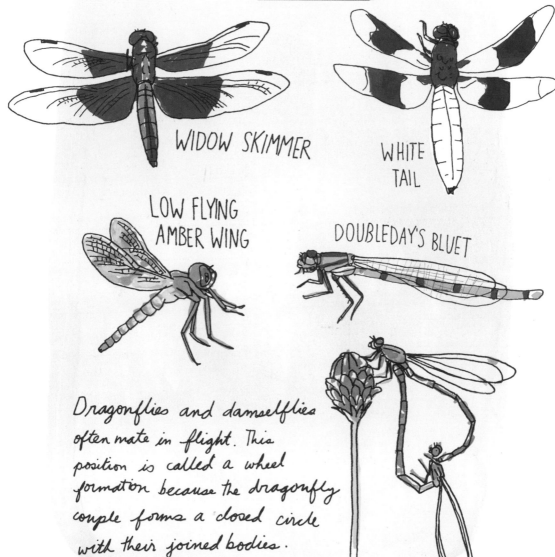

WIDOW SKIMMER

WHITE TAIL

LOW FLYING AMBER WING

DOUBLEDAY'S BLUET

Dragonflies and damselflies often mate in flight. This position is called a wheel formation because the dragonfly couple forms a closed circle with their joined bodies.

# ❧SPECTACULAR❧ SPIDERS

Spiders have been around for at least 500 times longer than humans. They belong to the class Arachnida along with scorpions, ticks, and mites. Unlike insects, spiders have only two major body sections and no antennae.

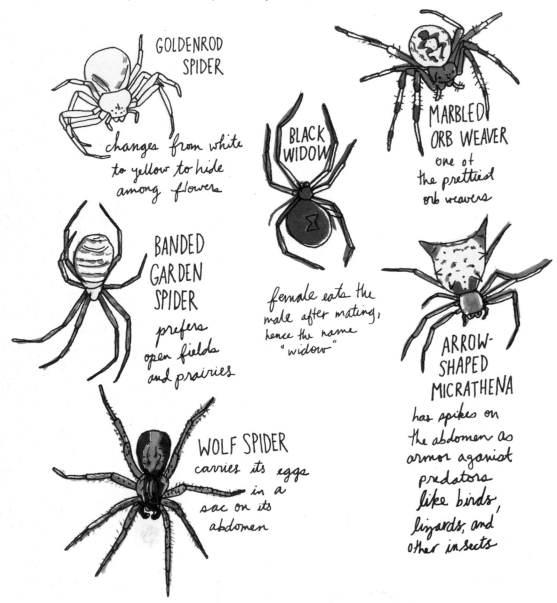

GOLDENROD SPIDER

changes from white to yellow to hide among flowers

BLACK WIDOW

female eats the male after mating, hence the name "widow"

MARBLED ORB WEAVER

one of the prettiest orb weavers

BANDED GARDEN SPIDER

prefers open fields and prairies

ARROW-SHAPED MICRATHENA

has spikes on the abdomen as armor against predators like birds, lizards, and other insects

WOLF SPIDER

carries its eggs in a sac on its abdomen

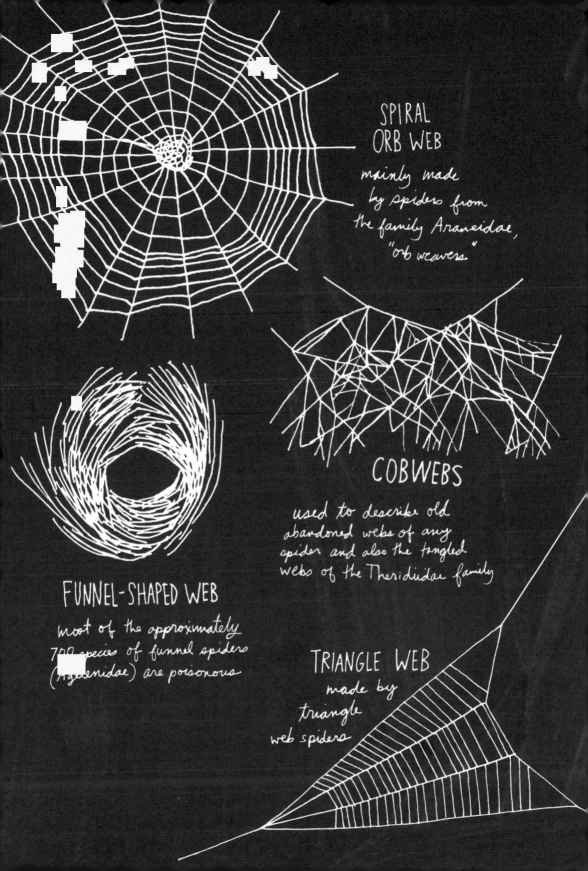

# SPIRAL ORB WEB

mainly made by spiders from the family Araneidae, "orb weavers."

# COBWEBS

used to describe old abandoned webs of any spider and also the tangled webs of the Theridiidae family

# FUNNEL-SHAPED WEB

most of the approximately 700 species of funnel spiders (Agelenidae) are poisonous

# TRIANGLE WEB

made by triangle web spiders

# ANATOMY OF AN ANT

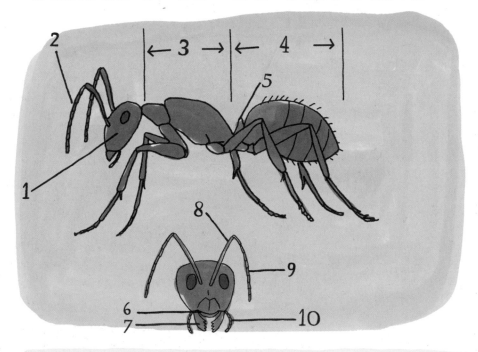

1. **head** - contains the mouth, mandibles, eyes, and antenna
2. **antenna** - used to smell, recognize nest mates, and detect enemies
3. **thorax** - middle region where the three pairs of legs are connected
4. **abdomen or gaster** - contains the vital organs and reproductive parts
5. **petiole** - connects the thorax to the abdomen
6. **labrum** - floor of the mouth
7. **mandible** - used for digging, carrying, and collecting food and building nests
8. **shaft** - base of the antenna
9. **lash** - segmented top of the antenna used for smell
10. **labial palp** - serves the function of a lower lip

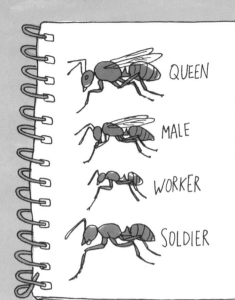

QUEEN

MALE

WORKER

SOLDIER

Ants have successfully colonized almost every landmass on earth. They evolved from wasp-like creatures about 120 million years ago and their social structures still resemble those of bee colonies.

ANTS TAKE HONEYDEW FROM APHIDS

At first glance, ants seem to treat their dead in the same way as humans – the carcass is untouched for two days before it is moved because the ants don't recognize the ant as dead until it starts emitting a chemical called oleic acid. Once they pick up that scent, the decaying ant, which now smells foreign, is carted off to the dump pile. The entomologist Edward O. Wilson found that if you put oleic acid on a live ant, the other ants will think it's dead and carry it away.

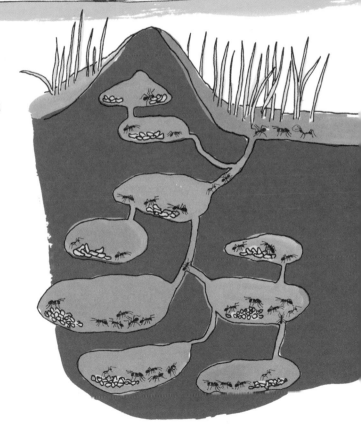

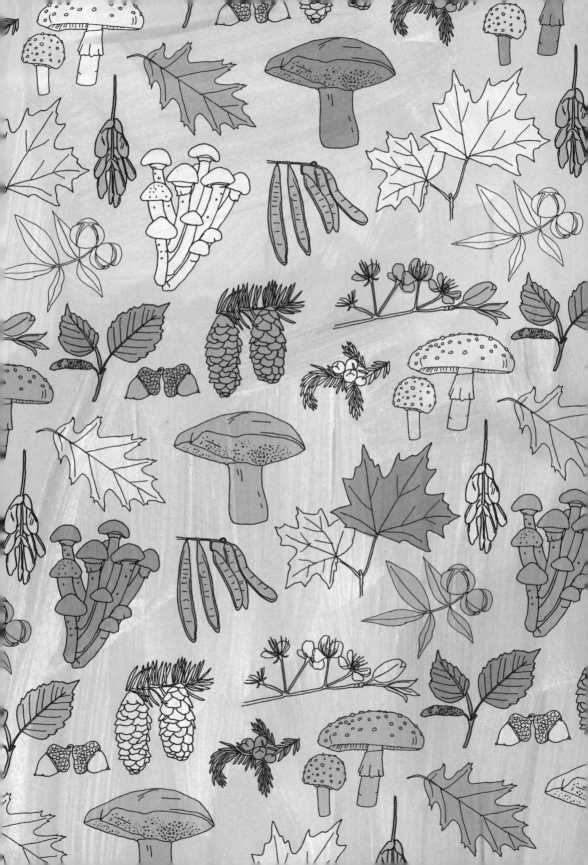

CHAPTER 4

*Take a Hike*

# Tree Shapes

PYRAMIDAL

CONICAL

COLUMNAR

BROAD

VASE

WEEPING

ROUNDED

OPEN

IRREGULAR

# ANATOMY OF A DECIDUOUS TREE

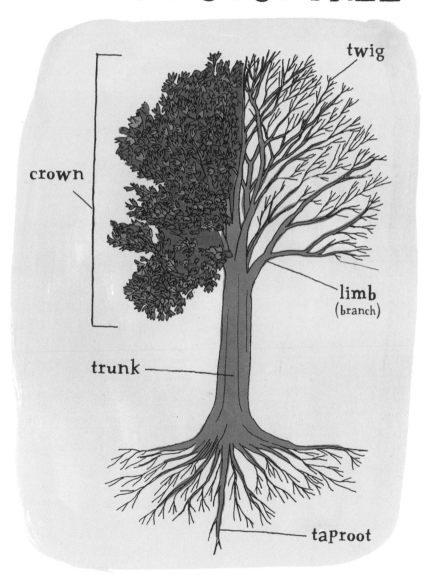

crown

twig

limb
(branch)

trunk

taproot

# ANATOMY OF A TRUNK

**SAPWOOD**
transports nutrients and water from the roots. This movement of substances is called translocation.

**HEARTWOOD**
is composed of inactive cells, providing structural support at the center of the tree.

**CAMBIUM**
is the actively growing layer where cells multiply quickly, forming either wood or bark.

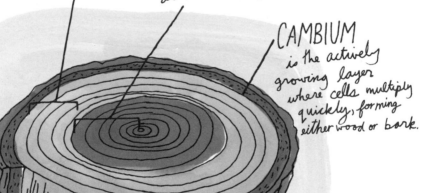

**OUTER BARK**
has a protective layer of inactive cells.

**INNER BARK**
carries food made in the leaves to the cambium and storage cells.

# Dendrochronology

(DETERMINING THE AGE OF A TREE BY COUNTING THE GROWTH RINGS IN A CROSS-SECTION OF ITS TRUNK)

New growth appears as rings in cross-sections of a tree's cambium layer, where one ring usually marks the passage of one year. Trees growing in temperate zones with distinct summers and winters develop the clearest rings. A long, wet growing season will result in trees having wider rings. Dry years create very thin rings.

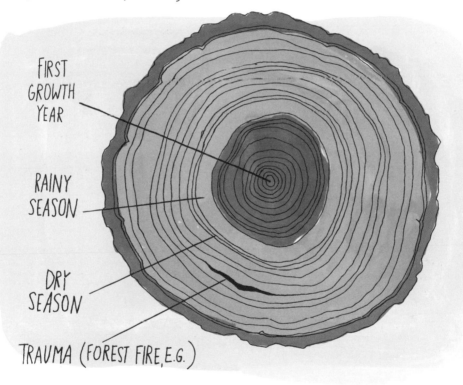

FIRST GROWTH YEAR

RAINY SEASON

DRY SEASON

TRAUMA (FOREST FIRE, E.G.)

The oldest living tree recorded is named "The Hatch Tree." It was cored to reveal 5,063 rings. It's a Great Basin bristlecone pine located in the White Mountains of California.

# LEAF IDENTIFICATION

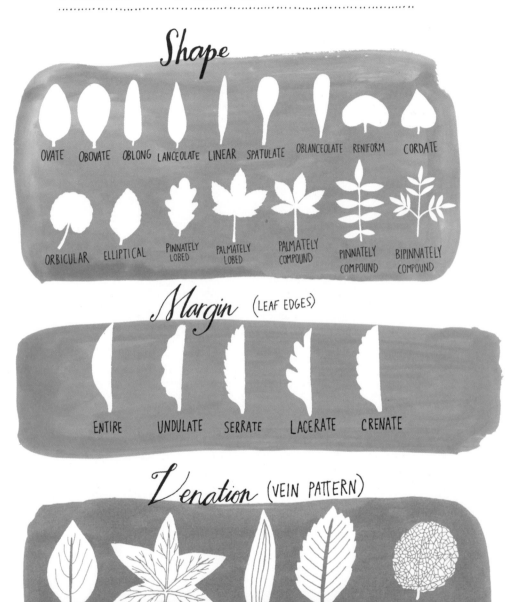

## Shape

OVATE · OBOVATE · OBLONG · LANCEOLATE · LINEAR · SPATULATE · OBLANCEOLATE · RENIFORM · CORDATE

ORBICULAR · ELLIPTICAL · PINNATELY LOBED · PALMATELY LOBED · PALMATELY COMPOUND · PINNATELY COMPOUND · BIPINNATELY COMPOUND

## Margin (LEAF EDGES)

ENTIRE · UNDULATE · SERRATE · LACERATE · CRENATE

## Venation (VEIN PATTERN)

ARCUATE · PALMATE · PARALLEL · PINNATE · RETICULATE

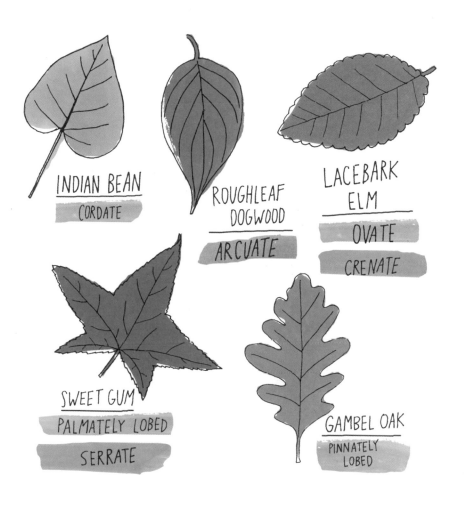

INDIAN BEAN
CORDATE

ROUGHLEAF DOGWOOD
ARCUATE

LACEBARK ELM
OVATE
CRENATE

SWEET GUM
PALMATELY LOBED
SERRATE

GAMBEL OAK
PINNATELY LOBED

Parts of a Leaf

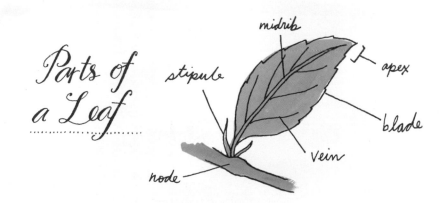

midrib
stipule
apex
blade
vein
node

# NORTH AMERICAN ❧ TREES ❧

## Giant Sequoia

**(SEQUOIADENDRON GIGANTEUM)**

Sequoias have the widest trunks and a mature tree's 11,000 cones may produce up to 400,000 seeds per year.

**WIDEST**

## Coast Redwood

**(SEQUOIA SEMPERVIRENS)**

This species has the tallest living trees with heights that reach 379 feet.

**TALLEST**

## Bristlecone Pine

**(PINUS ARISTATA)**

This pine lives longer than any other known organism — up to 5,000 years!

**OLDEST**

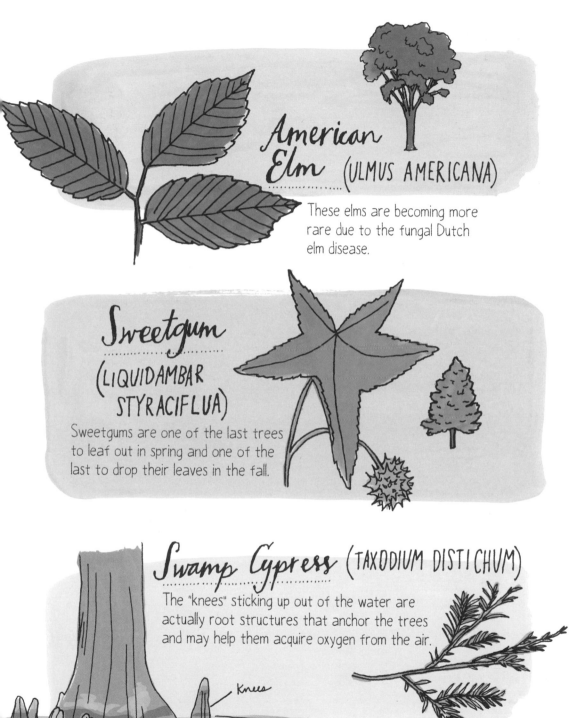

## American Elm (ULMUS AMERICANA)

These elms are becoming more rare due to the fungal Dutch elm disease.

## Sweetgum

### (LIQUIDAMBAR STYRACIFLUA)

Sweetgums are one of the last trees to leaf out in spring and one of the last to drop their leaves in the fall.

## Swamp Cypress (TAXODIUM DISTICHUM)

The "knees" sticking up out of the water are actually root structures that anchor the trees and may help them acquire oxygen from the air.

Knees

## Southern Live Oak

### (QUERCUS VIRGINIANA)

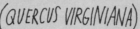

This is one of the few oaks regularly wider than it is tall.

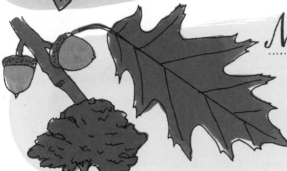

## Northern Red Oak

### (QUERCUS RUBRA)

Individual trees can live up to 500 years in optimal conditions.

## Weeping Willow

### (SALIX BABYLONICA)

A staple of Native American medicine, the sap contains salicylic acid, the active ingredient in aspirin.

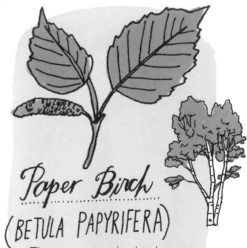

## Paper Birch

### (BETULA PAPYRIFERA)

This tree provides birch syrup, a sweetener made by boiling down the sap.

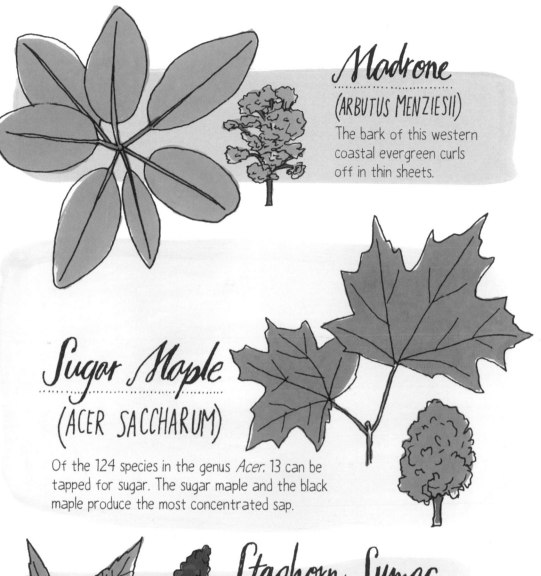

# Madrone

## (ARBUTUS MENZIESII)

The bark of this western coastal evergreen curls off in thin sheets.

# Sugar Maple

## (ACER SACCHARUM)

Of the 124 species in the genus *Acer*, 13 can be tapped for sugar. The sugar maple and the black maple produce the most concentrated sap.

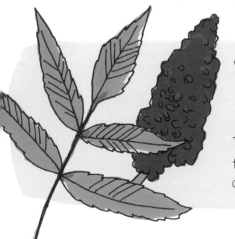

# Staghorn Sumac

## (RHUS TYPHINA)

The fruit has a pleasant citrus-like sourness that, when soaked and sweetened, makes a delicious late-summer drink.

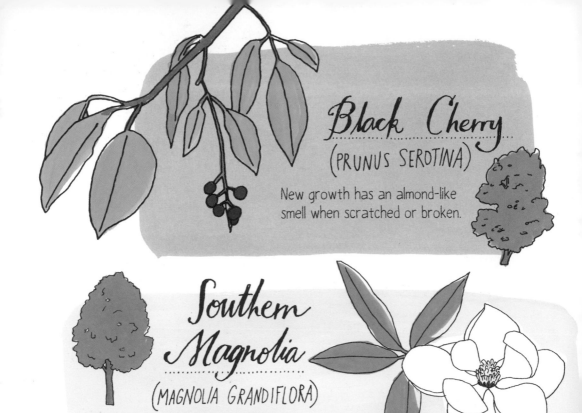

# Black Cherry
## (PRUNUS SEROTINA)

New growth has an almond-like smell when scratched or broken.

# Southern Magnolia
## (MAGNOLIA GRANDIFLORA)

The fragrant white flowers can be as big as 12 inches in diameter.

# Ginkgo
## (GINKGO BILOBA)

The ginkgo is truly unique in that it is the only species of its kind.

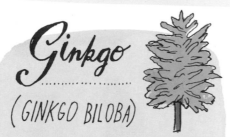

# Ponderosa Pine
## (PINUS PONDEROSA)

This pine tree has evolved to survive brush fires. Bark from furrows in the trunk is said to smell like vanilla.

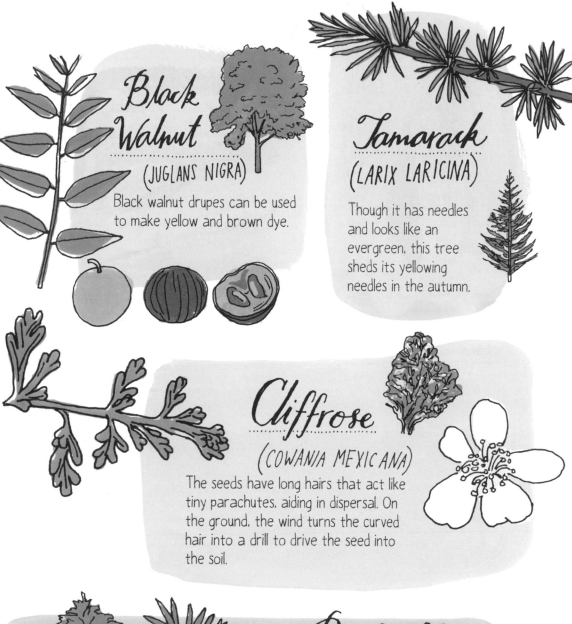

# Black Walnut
## (JUGLANS NIGRA)

Black walnut drupes can be used to make yellow and brown dye.

# Tamarack
## (LARIX LARICINA)

Though it has needles and looks like an evergreen, this tree sheds its yellowing needles in the autumn.

# Cliffrose
## (COWANIA MEXICANA)

The seeds have long hairs that act like tiny parachutes, aiding in dispersal. On the ground, the wind turns the curved hair into a drill to drive the seed into the soil.

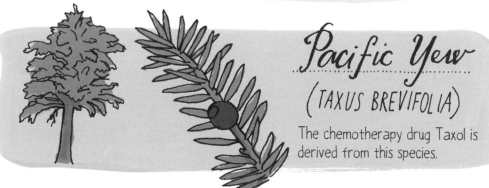

# Pacific Yew
## (TAXUS BREVIFOLIA)

The chemotherapy drug Taxol is derived from this species.

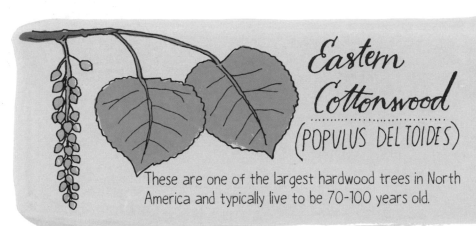

## Eastern Cottonwood
### (POPULUS DELTOIDES)

These are one of the largest hardwood trees in North America and typically live to be 70-100 years old.

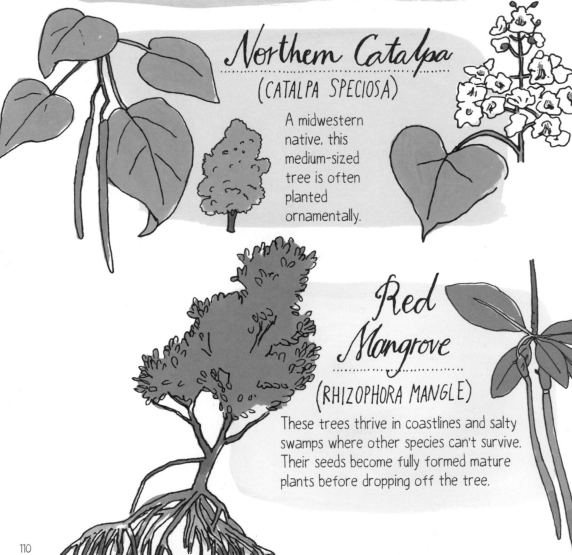

## Northern Catalpa
### (CATALPA SPECIOSA)

A midwestern native, this medium-sized tree is often planted ornamentally.

## Red Mangrove
### (RHIZOPHORA MANGLE)

These trees thrive in coastlines and salty swamps where other species can't survive. Their seeds become fully formed mature plants before dropping off the tree.

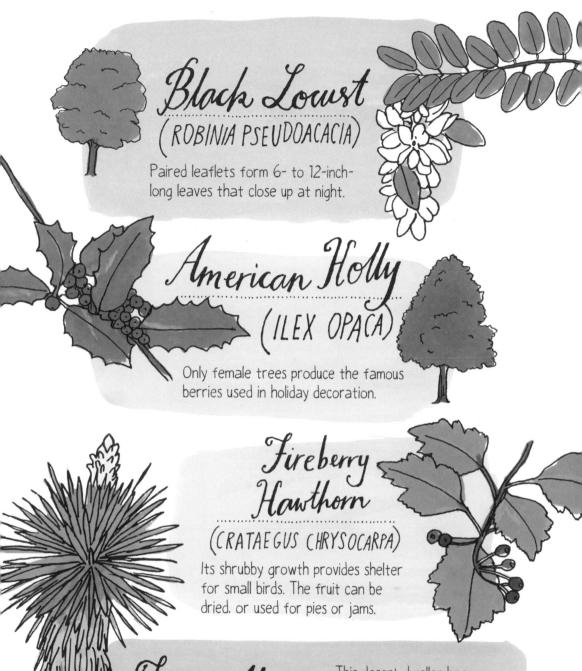

# Black Locust
## (ROBINIA PSEUDOACACIA)

Paired leaflets form 6- to 12-inch-long leaves that close up at night.

# American Holly
## (ILEX OPACA)

Only female trees produce the famous berries used in holiday decoration.

# Fireberry Hawthorn
## (CRATAEGUS CHRYSOCARPA)

Its shrubby growth provides shelter for small birds. The fruit can be dried, or used for pies or jams.

# Faxon Yucca
## (YUCCA FAXONIANA)

This desert dweller has spiked leaves up to 4½ feet long and a flower head of creamy blossoms as long as two feet.

# ❧ BEAUTIFUL BARK ❧

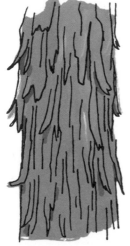

## Shagbark Hickory
### (CARYA OVATA)

## Flowering Dogwood
### (CORNUS FLORIDA)

## Northern White Cedar
### (THUJA OCCIDENTALIS)

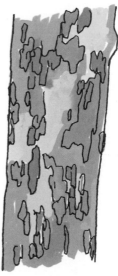

## Sycamore
### (PLATANUS OCCIDENTALIS)

## Hercules' Club
### (ZANTHOXYLUM CLAVA-HERCULIS)

## White Poplar
### (POPULUS ALBA)

## Winged Elm
### (ULMUS ALATA)

## Hackberry
### (CELTIS OCCIDENTALIS)

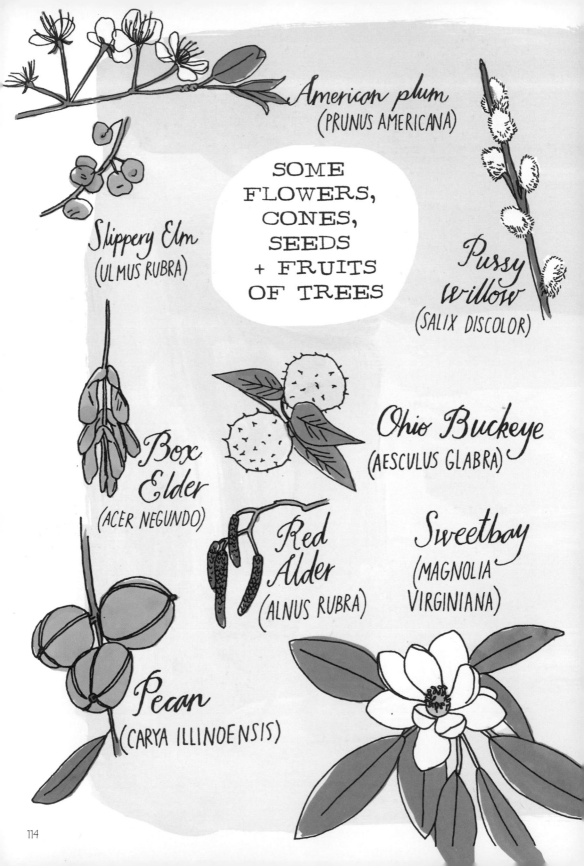

American plum
(PRUNUS AMERICANA)

Slippery Elm
(ULMUS RUBRA)

SOME
FLOWERS,
CONES,
SEEDS
+ FRUITS
OF TREES

Pussy
willow
(SALIX DISCOLOR)

Box
Elder
(ACER NEGUNDO)

Ohio Buckeye
(AESCULUS GLABRA)

Red
Alder
(ALNUS RUBRA)

Sweetbay
(MAGNOLIA
VIRGINIANA)

Pecan
(CARYA ILLINOENSIS)

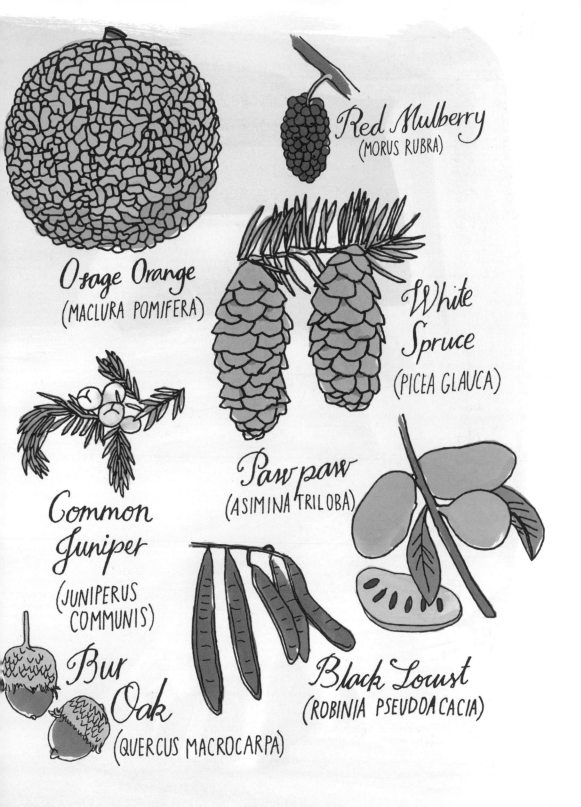

Red Mulberry
(MORUS RUBRA)

Osage Orange
(MACLURA POMIFERA)

White
Spruce
(PICEA GLAUCA)

Common
Juniper

(JUNIPERUS
COMMUNIS)

Paw paw
(ASIMINA TRILOBA)

Bur
Oak
(QUERCUS MACROCARPA)

Black Locust
(ROBINIA PSEUDOACACIA)

# Printing Patterns

## TOOLS

- Brayer
- Printing ink
- Palette
- Paper or fabric to print on
- Scratch paper

## INSTRUCTIONS

Collect interesting leaves, twigs, plants, flowers. Make sure not to pick endangered species or take too much of one plant.

Pour some ink on your palette, then roll the roller back and forth through the ink until it's evenly covered. It should make a sticky noise.

Place your leaf on a piece of scratch paper and directly roll over it with the brayer. Cover the entire surface as evenly as you can.

Press the ink-covered object onto the paper or fabric, pressing down on the entire surface to ensure it transfers. Peel it back slowly to reveal your print.

## TIPS

Experiment with pressure. Sometimes it's nicer to have a very faint print than a mushy thick one. Try pressing the paper on to the inked objects instead and see if the result differs.

Play with the design: use lots of objects in the same color or one object in several different colors, or create a repeating pattern.

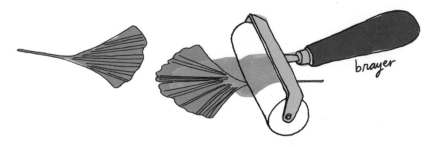

brayer

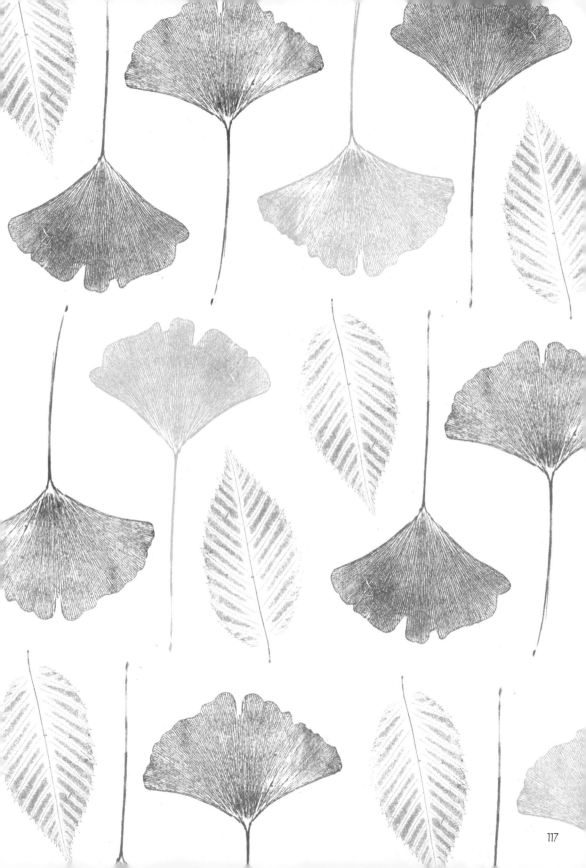

# ANATOMY OF A FERN

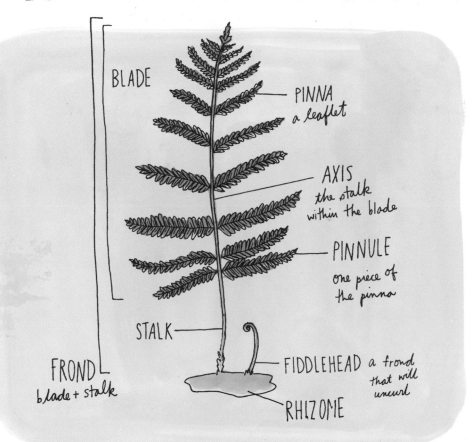

BLADE

PINNA
a leaflet

AXIS
the stalk
within the blade

PINNULE
one piece of
the pinna

STALK

FROND
blade + stalk

FIDDLEHEAD a frond
that will
uncurl

RHIZOME

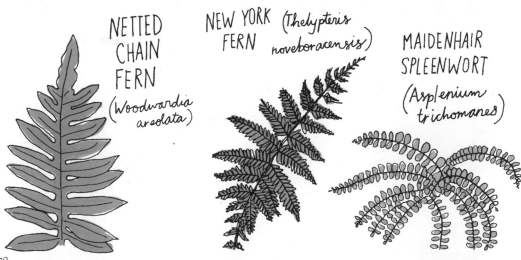

NETTED
CHAIN
FERN
(Woodwardia
areolata)

NEW YORK (Thelypteris
FERN noveboracensis)

MAIDENHAIR
SPLEENWORT
(Asplenium
trichomanes)

# ✳ PRETTY, PRETTY LICHEN ✳

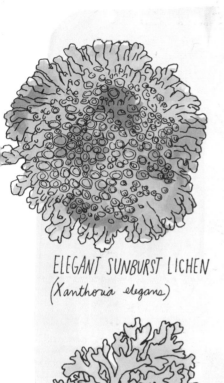

Lichens are a fascinating union of fungus and algae living as one organism. Lichens are not bright green like mosses and lack a leafy structure.

Though they grow all over the world under extreme natural environments like deserts, arctic tundra, and sea-battered coasts, lichens are also good pollution indicators, often refusing to grow in areas with congested urban air.

It's estimated that lichen covers up to 6 percent of the earth's land surface.

ELEGANT SUNBURST LICHEN
(Xanthoria elegans)

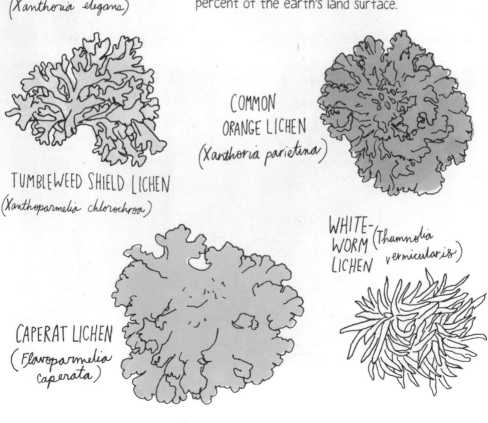

COMMON ORANGE LICHEN
(Xanthoria parietina)

TUMBLEWEED SHIELD LICHEN
(Xanthoparmelia chlorochroa)

WHITE-WORM LICHEN (Thamnolia vermicularis)

CAPERAT LICHEN
(Flavoparmelia caperata)

# ❧ MYSTERIOUS MOSSES ❧

Mosses are small, spore-producing plants with simple leaves and no flowers or seeds. They don't even have proper roots to collect moisture and nutrients. Mosses grow in clumps in shady and moist locations. You can often find them on the north-facing sides of trees.

Tiny insects like mites and springtails are drawn to the scent of moss and help spread its spores.

Tons of sphagnum moss were used in World War I to treat wounds as surgical dressing. Sphagnum can absorb up to 20 times its dry weight in moisture.

STAR MOSS
(Atrichum angustatum)

TREE MOSS
(Climacium americanum)

SPOON-LEAVED MOSS
(Bryoandersonia illecebra)

PINCUSHION MOSS
(Leucobryum glaucum)

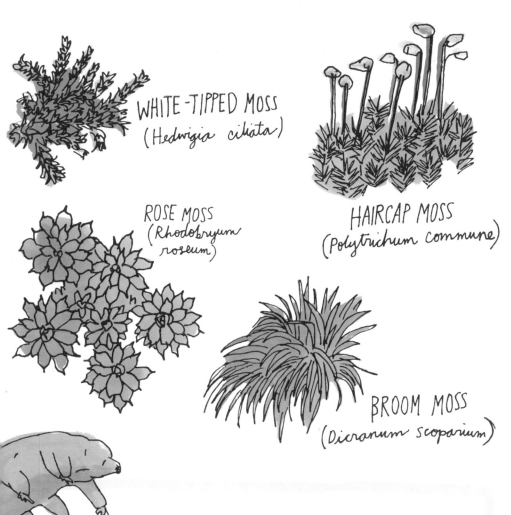

WHITE-TIPPED MOSS
(Hedwigia ciliata)

HAIRCAP MOSS
(Polytrichum commune)

ROSE MOSS
(Rhodobryum
roseum)

BROOM MOSS
(Dicranum scoparium)

# WATERBEARS

Waterbears (also called tardigrades) are eight-legged micro-animals that often live and feed on mosses and lichens. Waterbears may be the most adaptable animals in the world. They can live within a temperature range of -300°F to 300°F, can be dried out to three percent water, survive 6,000 atmospheres of pressure, withstand radiation bombardment at levels that would kill any other animal, and survive the harsh environment of outer space. Plus they're kind of cute!

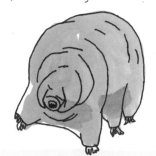

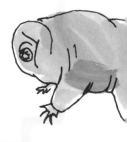

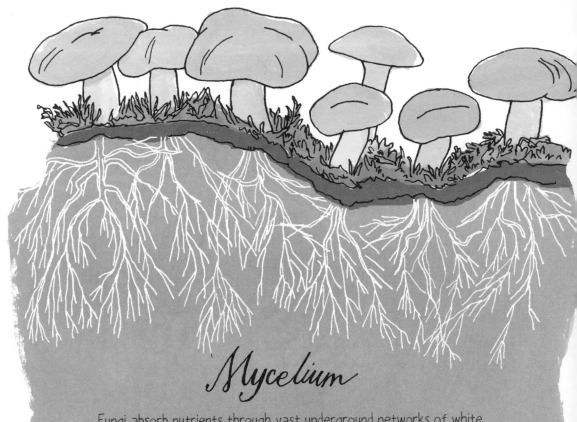

# Mycelium

Fungi absorb nutrients through vast underground networks of white branching threads called mycelium. Though hidden in the soil and sometimes mistaken for roots, mycelium is actually the proper body of a fungus. Mushrooms are the fruit, appearing only when conditions for spreading their spores are just right.

Mycelium plays a vital role in the decomposition of plant material but also can form a symbiotic relationship, called mycorrhiza, with the roots of a plant. Most plants depend on mycorrhiza to absorb phosphorus and other nutrients. In exchange, fungi gain constant access to the plants' carbohydrates.

A patch of mycelium in eastern Oregon estimated to be the size of 1,665 football fields and 2,200 years old, is a contender for the title of world's largest and oldest organism.

# ANATOMY OF A MUSHROOM

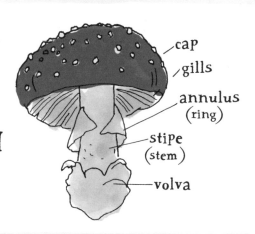

- cap
- gills
- annulus (ring)
- stipe (stem)
- volva

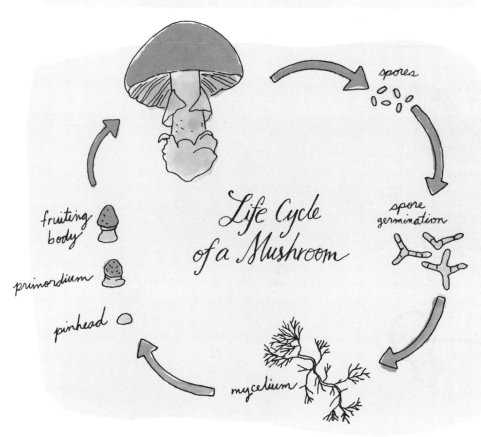

*Life Cycle of a Mushroom*

- spores
- spore germination
- mycelium
- pinhead
- primordium
- fruiting body

# MARVELOUS MUSHROOMS

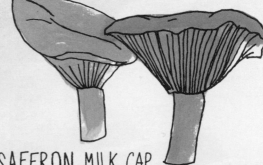

## SLIPPERY JACK
### (Suillus luteus)

Instead of gills, these mushrooms have spore-dispersing tubes on their undersides.

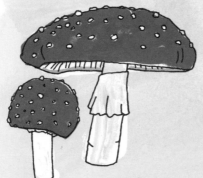

## FLY AGARIC
### (Amanita muscaria)

Luckily, this is one of the most easily recognizable fungi because it's fatally poisonous if eaten.

## SAFFRON MILK CAP
### (Lactarius deliciosus)

This orange edible becomes a dull green when bruised or old.

## HONEY MUSHROOMS
### (Armillaria mellea)

These grow in clusters on decaying wood. Its mycelia are bioluminescent (that is, they glow in the dark) and can be harmful to living trees.

## OYSTER MUSHROOM
### (Pleurotus ostreatus)

This choice edible mushroom grows in clusters, attached to trees like ears.

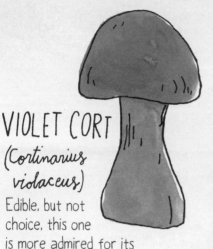

## VIOLET CORT
### (Cortinarius violaceus)

Edible, but not choice, this one is more admired for its beautiful color.

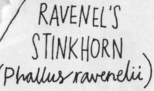

## RAVENEL'S STINKHORN
### (Phallus ravenelii)

It emits a slime that smells of rotting meat to attract flies and beetles for spore dispersal.

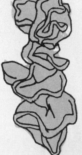

## WITCH'S BUTTER
### (Tremella mesenterica)

Edible but not very appealing, it can appear greasy and slimy and is sometimes called "yellow brain."

## SHAGGY CHANTERELLE
### (Gomphus floccosus)

This one can be toxic.

## HEN OF THE WOODS
### (Grifola frondosa)

This tasty species grows in clumps at the base of oaks. Also called maitake.

## INKY CAP
### (Coprinopsis atramentaria)

It releases a liquid that can be used as ink. Edible but causes acute sensitivity to alcohol..

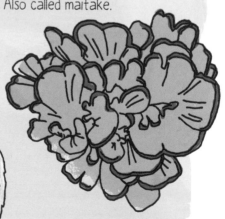

# ROTTING LOG

A dead tree on the forest floor may not look like much, but the decomposing wood hosts a party of plant and animal life. Many kinds of insect larvae burrow into decaying wood to take shelter from the winter. Snails and slugs delight in the debris and fungi growing from rotting logs. Earthworms digest vast quantities of rotting organic matter, leaving behind nutrient-rich casts. Moist decomposing wood is a perfect nutrient nursery from which lichens, mosses, flowers, and even other trees can set root and thrive.

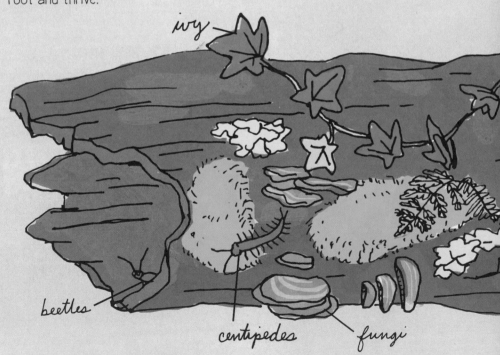

ivy

beetles

centipedes

fungi

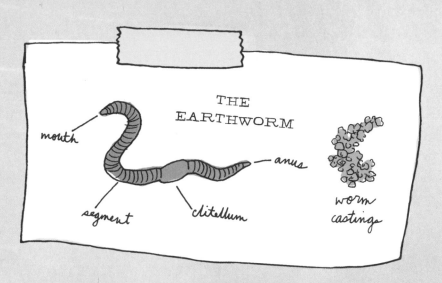

THE
EARTHWORM

mouth

anus

segment

clitellum

worm
castings

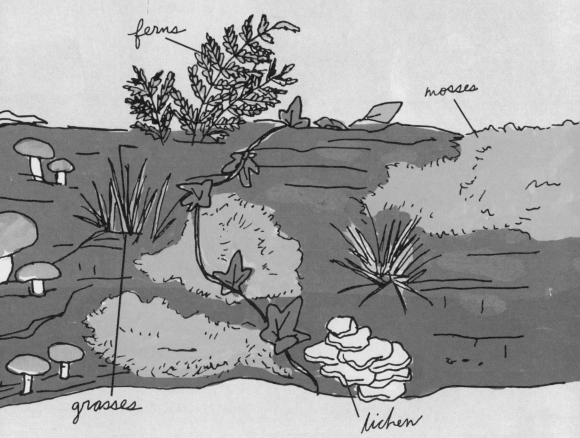

ferns

mosses

grasses

lichen

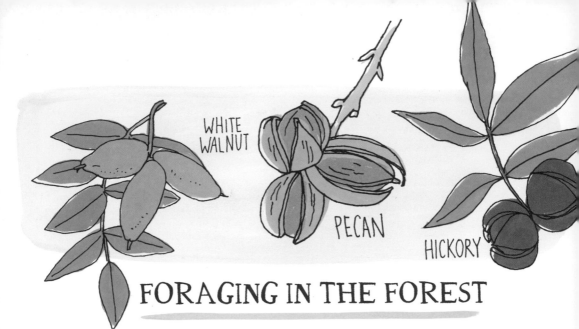

# FORAGING IN THE FOREST

The ancient practice of foraging in the forest for nuts, berries, and mushrooms is enjoying a resurgence, and fiddlehead ferns and wild ramps can now be found in many farmers' markets. Other forest edibles include acorns, balsam and spruce (inner bark), dogwood (berries), and chokeberry.

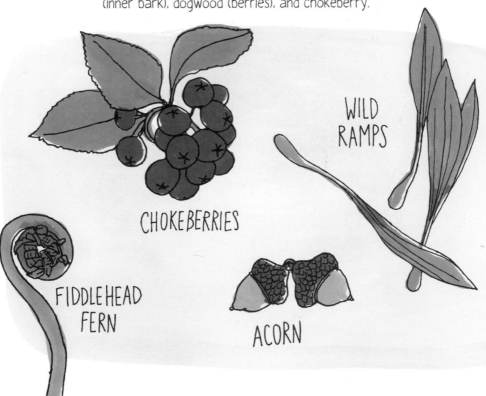

# Dry-Sautéed Bolete with Yellow Wood Sorrel and Thyme

1 POUND FRESH
KING BOLETE
MUSHROOMS

2 TABLESPOONS BUTTER

1 OUNCE WHITE WINE

1 SPRIG CHOPPED THYME

LEAVES AND FLOWERS OF
WILD YELLOW WOOD SORREL

SALT AND PEPPER

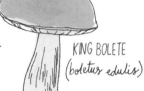

KING BOLETE
(boletus edulis)

Fresh mushrooms can become mushy when cooked. Dry-sautéeing leaves them beautifully browned and brings out their natural flavor and texture. It couldn't be simpler:

Gently clean dirt from the fungi with a soft pastry brush. Do not wash them unless absolutely necessary, and then only in a bit of cold water or with a damp cloth.

Slice the mushrooms 1/3" thick and place the pieces flat on a completely dry frying pan at medium-high heat. Stir occasionally to avoid sticking. Once the mushrooms are browned and most of the juices have evaporated, add the butter, wine, and thyme to the pan. Stir and cook for another couple of minutes as the mushrooms absorb the liquid.

Remove from heat and top with tangy flowers and leaves of yellow wood sorrel (there's probably some growing in your yard!). Salt and pepper to taste. Serve atop risotto or pasta.

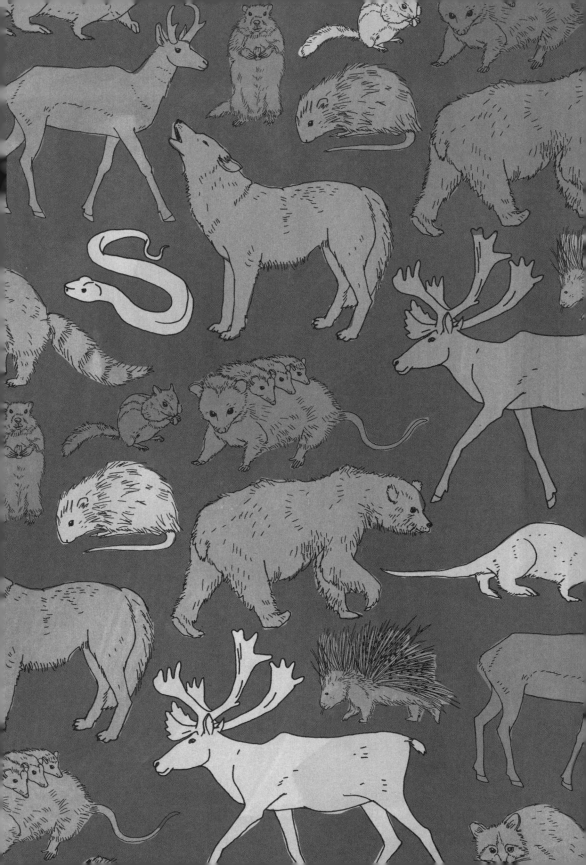

CHAPTER 5

# Creature Feature

# ANIMALS IN THE NEIGHBORHOOD

## Woodchuck

Woodchucks (or groundhogs) can climb trees if they need to escape.

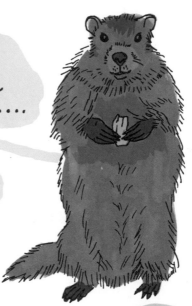

## Raccoon

Raccoons have 5 fingers but no thumbs on their highly sensitive paws. They are excellent swimmers.

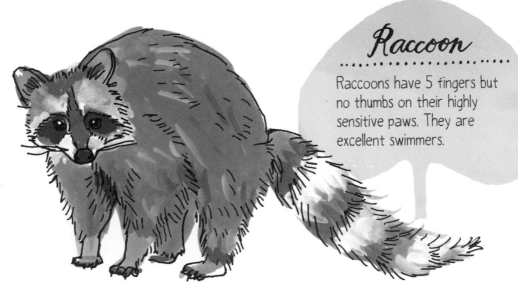

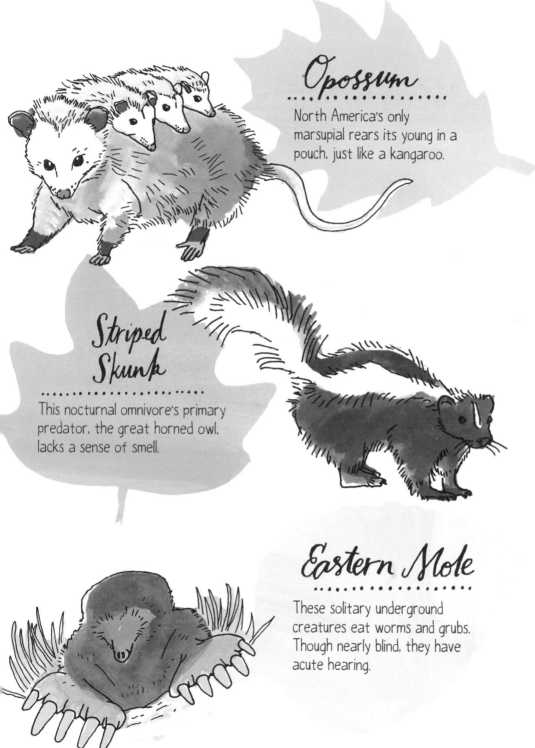

## Opossum

North America's only
marsupial rears its young in a
pouch, just like a kangaroo.

## Striped Skunk

This nocturnal omnivore's primary
predator, the great horned owl,
lacks a sense of smell.

## Eastern Mole

These solitary underground
creatures eat worms and grubs.
Though nearly blind, they have
acute hearing.

# ANATOMY OF A BAT

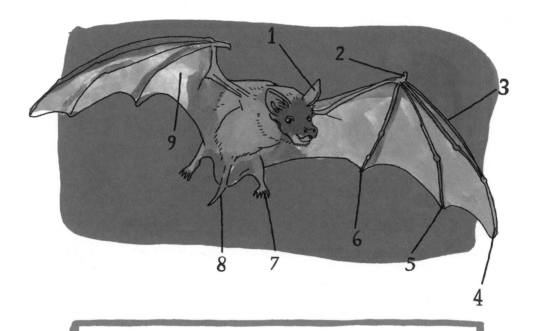

1. ear
2. thumb
3. second finger
4. third finger
5. fourth finger
6. fifth finger
7. foot
8. tail
9. membrane

Bats are the only mammals capable of true flight.

# ☙ COMMON NORTH AMERICAN BATS ☙

Twenty percent of all classified mammals are bats, with over 1,000 species identified. Insect-eating bats emit ultrasonic sounds to pinpoint with astonishing accuracy the location of their prey. Most larger bats consume fruit, helping to disperse seeds and pollen. There are three species of vampire bats that feed on the blood of animals, but they are rare.

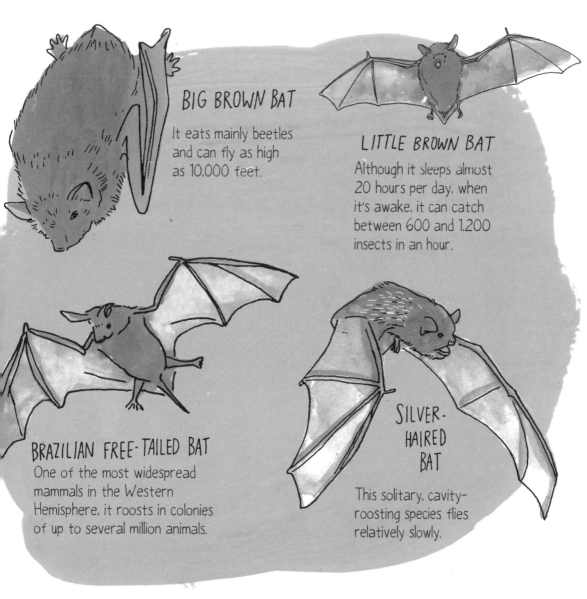

## BIG BROWN BAT

It eats mainly beetles and can fly as high as 10,000 feet.

## LITTLE BROWN BAT

Although it sleeps almost 20 hours per day, when it's awake, it can catch between 600 and 1,200 insects in an hour.

## BRAZILIAN FREE-TAILED BAT

One of the most widespread mammals in the Western Hemisphere, it roosts in colonies of up to several million animals.

## SILVER-HAIRED BAT

This solitary, cavity-roosting species flies relatively slowly.

# ❀ TREE SQUIRRELS ❀

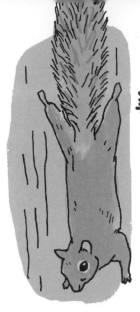

These squirrels are one of the very few mammals that can descend a tree headfirst.

**Eastern Gray Squirrel**

**American Red Squirrel**

Though their primary diet is pine and spruce cones, they also eat mushrooms, buds and flowers, and even bird eggs.

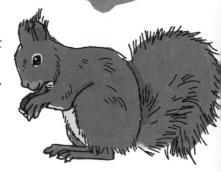

Not true fliers, these nocturnal squirrels glide downward between trees, gaining lift from flaps of skin on their sides. Most "flights" are 30 feet or less, but some flying squirrels have been observed gliding nearly 300 feet!

**Northern Flying Squirrel**

# ✿ GROUND SQUIRRELS ✿

## Yellow-Bellied Marmot

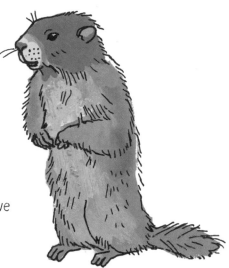

Rather than dig burrows, marmots live in rocky piles in mountainous areas.

Prairie dogs and marmots post sentinels by their burrows to spot predators. Warning calls and whistles identify whether a snake or a hawk is approaching.

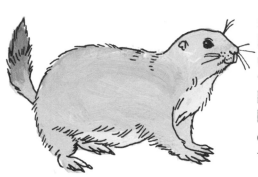

These extremely social animals live in elaborate underground "towns" that may house several hundred individuals divided into small family groups.

## Black-Tailed Prairie Dog

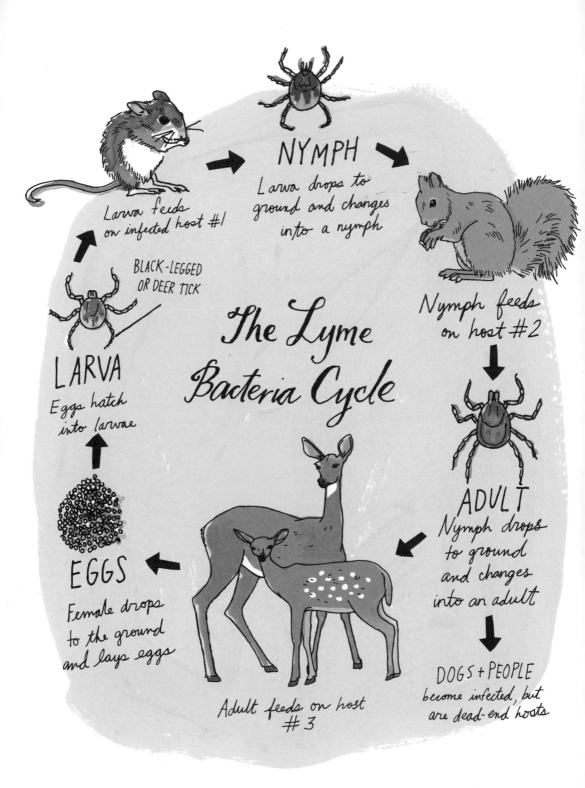

NYMPH

Larva drops to ground and changes into a nymph

Larva feeds on infected host #1

BLACK-LEGGED OR DEER TICK

LARVA

Eggs hatch into larvae

The Lyme Bacteria Cycle

Nymph feeds on host #2

ADULT

Nymph drops to ground and changes into an adult

DOGS + PEOPLE become infected, but are dead-end hosts

EGGS

Female drops to the ground and lays eggs

Adult feeds on host #3

## Black Bear

- weighs between 100 and 600 pounds
- upright ears
- flat shoulder
- rump higher than shoulder
- rounded (convex) profile

VS.

## Grizzly Bear

- weighs between 300 and 800 pounds
- rounder, shorter ears
- shoulder hump
- sloping rump
- dished (concave) profile

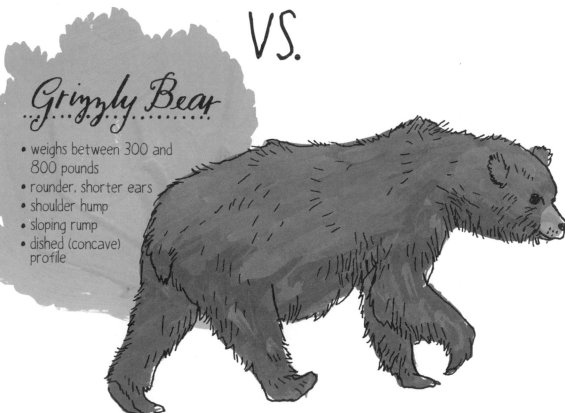

## Bushy-Tailed Woodrat

With a fondness for shiny objects, these woodrats sometimes pick up a bottle cap, coin, or bit of foil over food.

## Plains Pocket Gopher

This subterranean dweller has large cheek pouches for carrying food and long teeth that are visible even when its mouth is closed.

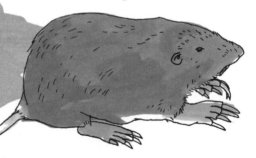

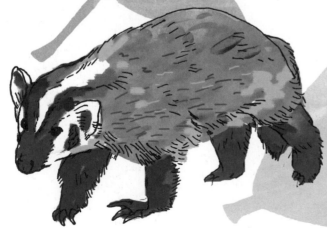

## Badger

Badgers are such strong burrowers that they can dig themselves into underground hiding within moments of any threat.

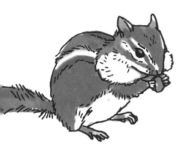

Chipmunks pack food into their expandable cheek pouches and carry it back to their lairs. They dig extensive burrows with "rooms" separated by function: bedroom, pantry, latrine, nursery.

Eastern Chipmunk

This is the smallest and also the most widespread North American chipmunk. They don't hibernate but go into a state of torpor, or decreased physiological activity, for extended periods of time.

Least Chipmunk

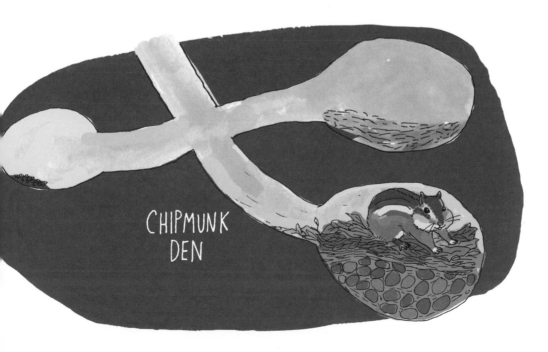

CHIPMUNK DEN

# ❧ SNAKES ❧

GARTER

COTTONMOUTH

COPPERHEAD

MUD SNAKE

SCARLET SNAKE

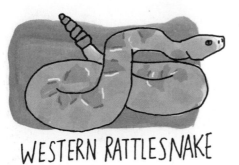

WESTERN RATTLESNAKE

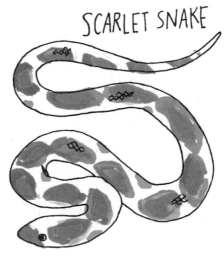

 = venomous

# ❧ LIZARDS ❧

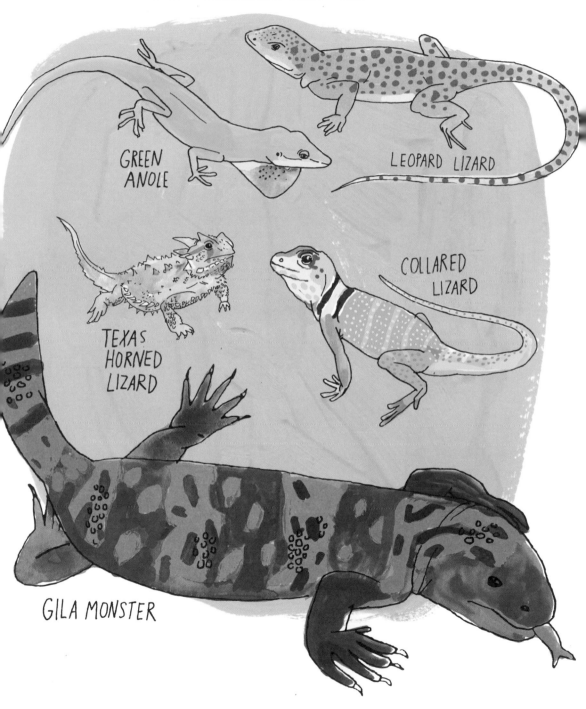

LEOPARD LIZARD

GREEN
ANOLE

TEXAS
HORNED
LIZARD

COLLARED
LIZARD

GILA MONSTER

# WILD CATS

## Mountain Lion

More closely related to the domestic cat than the lion, the mountain lion's range extends from northern Canada to southern South America.

## Lynx

In the snowy north, a lynx's paw may be larger than a human's hand.

## Bobcat

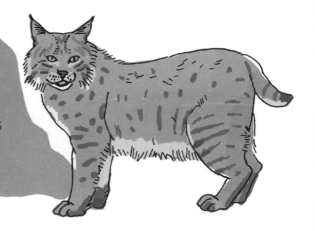

Named for its stubby tail, the bobcat is smaller than its northern lynx cousin and lacks the distinctive ear tufts.

# ❧WILD DOGS❧

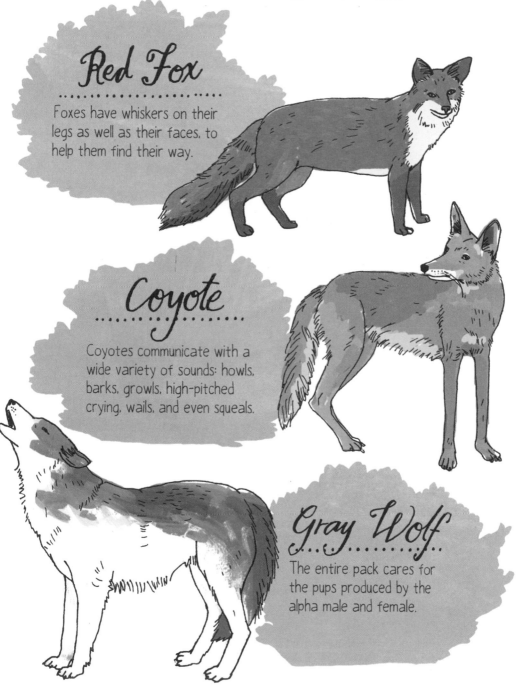

## Red Fox

Foxes have whiskers on their legs as well as their faces, to help them find their way.

## Coyote

Coyotes communicate with a wide variety of sounds: howls, barks, growls, high-pitched crying, wails, and even squeals.

## Gray Wolf

The entire pack cares for the pups produced by the alpha male and female.

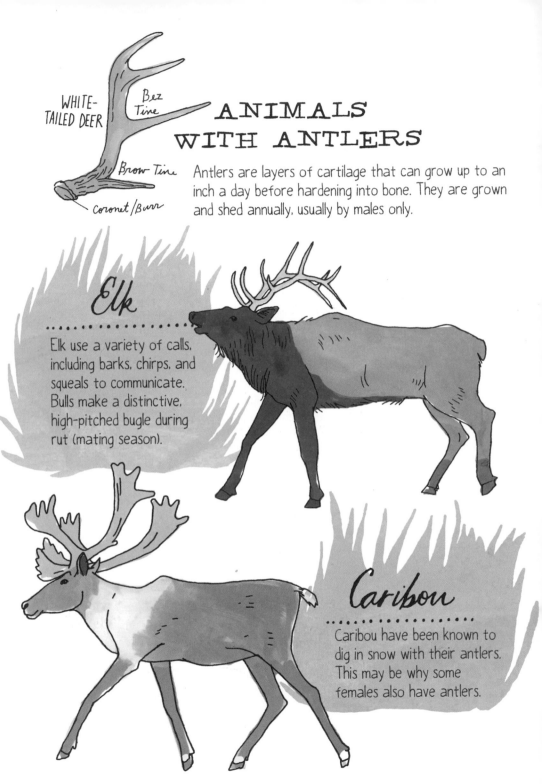

WHITE-TAILED DEER

Bez Tine

Brow Tine

Coronet / Burr

# ANIMALS WITH ANTLERS

Antlers are layers of cartilage that can grow up to an inch a day before hardening into bone. They are grown and shed annually, usually by males only.

## Elk

Elk use a variety of calls, including barks, chirps, and squeals to communicate. Bulls make a distinctive, high-pitched bugle during rut (mating season).

## Caribou

Caribou have been known to dig in snow with their antlers. This may be why some females also have antlers.

# ...AND HORNS

Horns are permanent appendages with a bony core covered by keratin. They are typically grown by both males and females and have rings that show the animal's age.

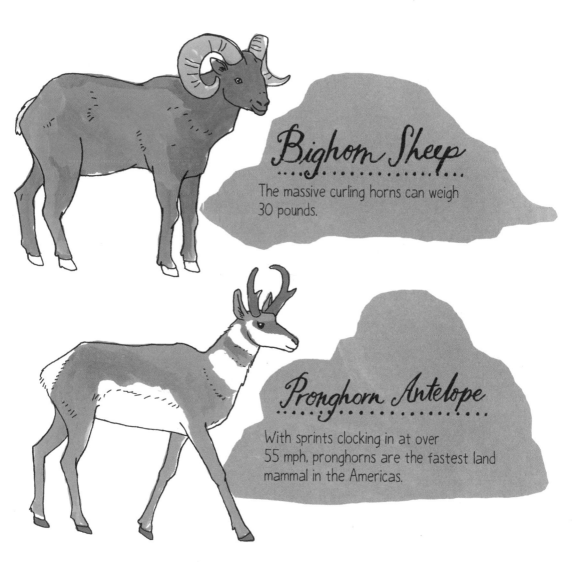

## Bighorn Sheep

The massive curling horns can weigh 30 pounds.

## Pronghorn Antelope

With sprints clocking in at over 55 mph, pronghorns are the fastest land mammal in the Americas.

# ☙ AQUATIC ❧ MAMMALS

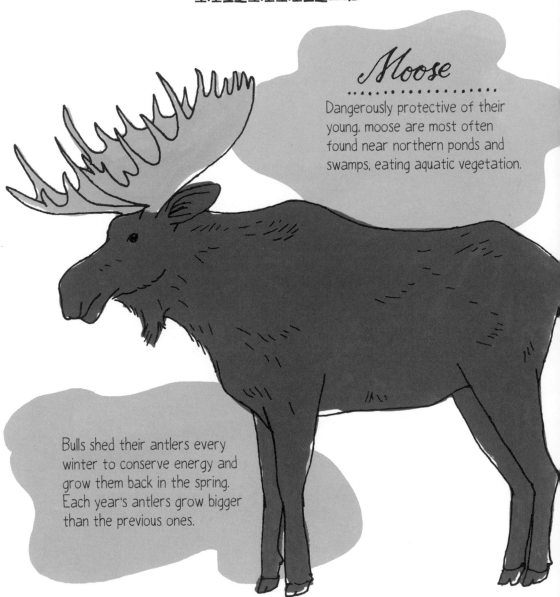

## Moose
. . . . . . . . . . . . . . . .
Dangerously protective of their young, moose are most often found near northern ponds and swamps, eating aquatic vegetation.

Bulls shed their antlers every winter to conserve energy and grow them back in the spring. Each year's antlers grow bigger than the previous ones.

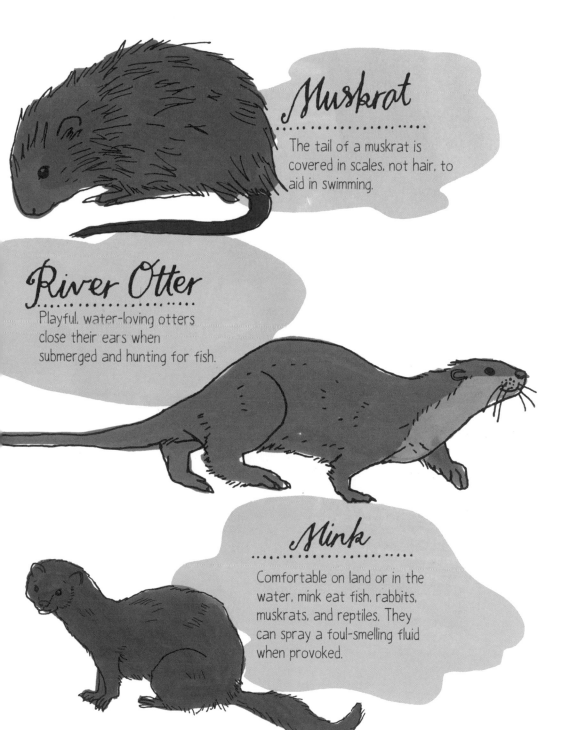

## Muskrat

The tail of a muskrat is covered in scales, not hair, to aid in swimming.

## River Otter

Playful, water-loving otters close their ears when submerged and hunting for fish.

## Mink

Comfortable on land or in the water, mink eat fish, rabbits, muskrats, and reptiles. They can spray a foul-smelling fluid when provoked.

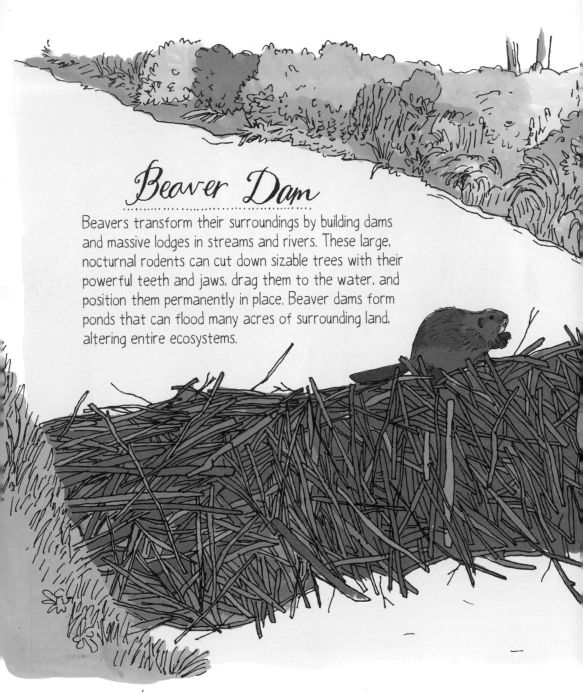

# Beaver Dam

Beavers transform their surroundings by building dams and massive lodges in streams and rivers. These large, nocturnal rodents can cut down sizable trees with their powerful teeth and jaws, drag them to the water, and position them permanently in place. Beaver dams form ponds that can flood many acres of surrounding land, altering entire ecosystems.

*Beavers are second only to humans in the impact they have on the natural environment.*

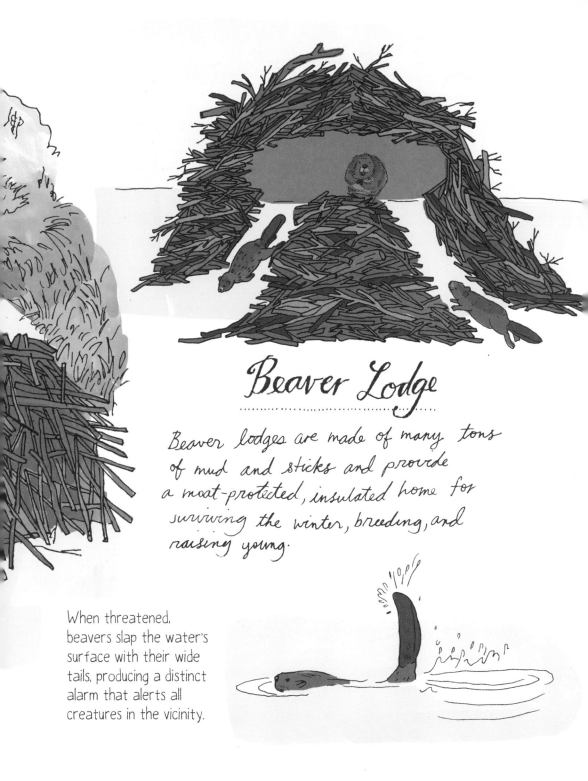

# Beaver Lodge

Beaver lodges are made of many tons of mud and sticks and provide a moat-protected, insulated home for surviving the winter, breeding, and raising young.

When threatened, beavers slap the water's surface with their wide tails, producing a distinct alarm that alerts all creatures in the vicinity.

# SALAMANDERS

"Salamander" is the name for a group of amphibians that have tails as adults, including newts and sirens. Most adult salamanders have neither lungs nor gills. They breathe through their skins and permeable membranes in their mouths.

## HELLBENDER

wrinkly skin provides more surface area for absorbing oxygen from the water

## TIGER SALAMANDER

is striped like a tiger and has two protruding tubercles on the soles of its feet

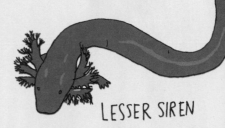

## LESSER SIREN

has visible gills its entire life

## SLIMY SALAMANDER

excretes a foul-tasting liquid to deter predators

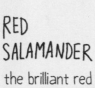

## RED SALAMANDER

the brilliant red of their youth fades as they age

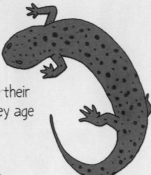

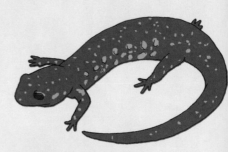

## EASTERN NEWT

can regenerate lost or damaged limbs, eyes, jaws, and some internal organs

# TURTLES

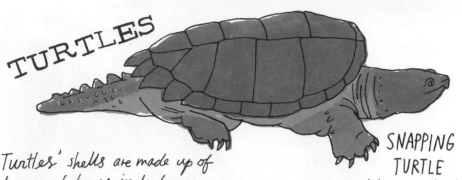

Turtles' shells are made up of dozens of bones, including outgrowths of the spine and ribs.

## SNAPPING TURTLE
cannot withdraw completely into its shell

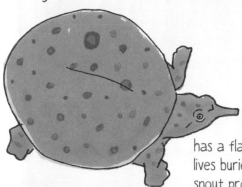

## SPINY SOFT TURTLE
has a flat, leathery shell and lives buried in mud with its pointy snout protruding

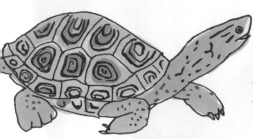

## DIAMONDBACK TERRAPIN
females sometimes twice the size of males

## WOOD TURTLE
feeds on mollusks, small animals, and plants

## PAINTED TURTLE
social and gregarious, often seen basking on logs together, sometimes on top of each other

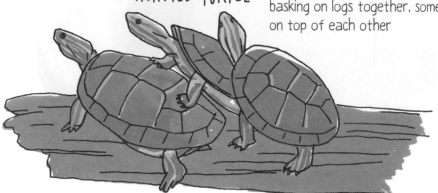

# ✤ OUTSTANDING ADAPTATIONS ✤

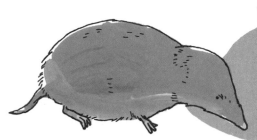

## Short-tailed Shrew

Shrews are among the smallest mammals in the world. This species has venomous saliva for protection and for subduing prey.

## Snow-shoe Hare

This seasonal chameleon has a stark white winter coat and a brown summer coat. Its name comes from the pads of matted hair on its feet for warmth and mobility on snow.

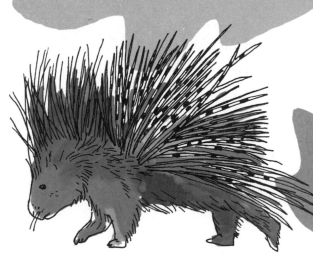

## Porcupine

The porcupine's 30,000 sharp quills are actually modified hairs with barbed tips.

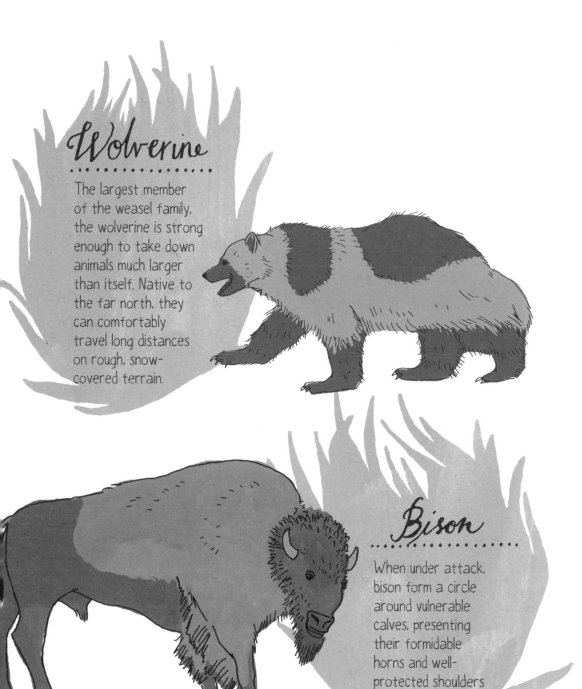

## Wolverine

The largest member of the weasel family, the wolverine is strong enough to take down animals much larger than itself. Native to the far north, they can comfortably travel long distances on rough, snow-covered terrain.

## Bison

When under attack, bison form a circle around vulnerable calves, presenting their formidable horns and well-protected shoulders to predators.

# ⚛ MARINE MAMMALS ⚛

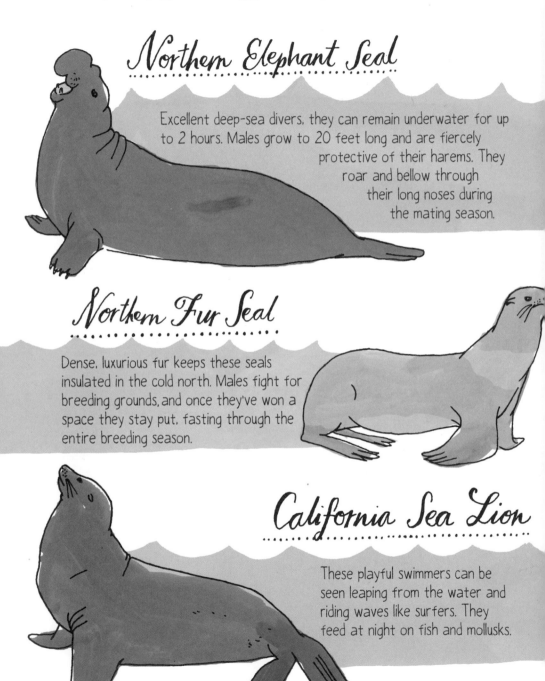

## Northern Elephant Seal

Excellent deep-sea divers, they can remain underwater for up to 2 hours. Males grow to 20 feet long and are fiercely protective of their harems. They roar and bellow through their long noses during the mating season.

## Northern Fur Seal

Dense, luxurious fur keeps these seals insulated in the cold north. Males fight for breeding grounds, and once they've won a space they stay put, fasting through the entire breeding season.

## California Sea Lion

These playful swimmers can be seen leaping from the water and riding waves like surfers. They feed at night on fish and mollusks.

# Manatee

Fond of the warm water flowing out of power plants, these slow-moving mammals graze on sea-bottom plants with their nimble, prehensile lips.

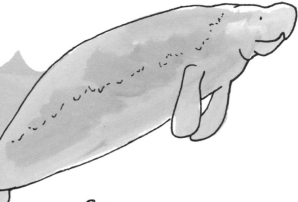

# Harbor Seal

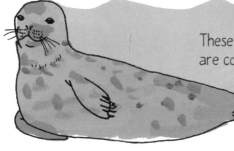

These seals spend a lot of time on shore and are comfortable mating on land or at sea. They've been known to give birth in the water.

# Sea Otter

The smallest marine mammal spends almost all of its time in the water. To crack mollusks open, an otter floats on its back and smashes shells against rocks it holds on its belly.

# Bottlenose Dolphin

These social creatures use echolocation to hunt. They communicate with body language and clicks and squeaks from their mouths and blowholes. They are known for their intelligence and willingness to interact with humans and recent research suggests that dolphins transmit cultural knowledge across generations.

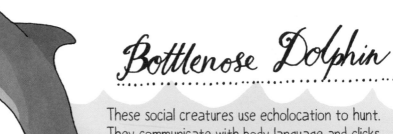

# Orca

Master pack hunters, orcas corral fish into tight coves where they are easy to catch. They hunt whales many times their size by chasing them down and taking bites until the whale succumbs.

# Harbor Porpoise

Elaborate courtship displays between males and females may involve intense vocalizations and playful touching.

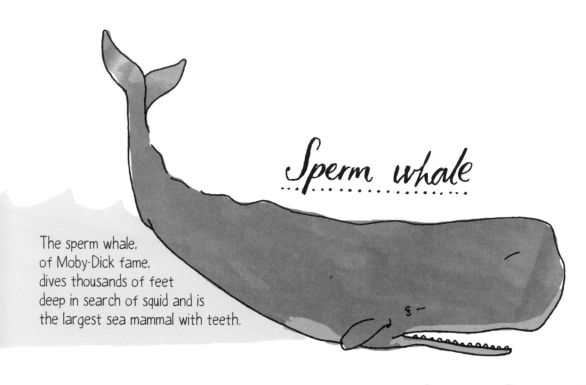

# Sperm whale

The sperm whale, of Moby-Dick fame, dives thousands of feet deep in search of squid and is the largest sea mammal with teeth.

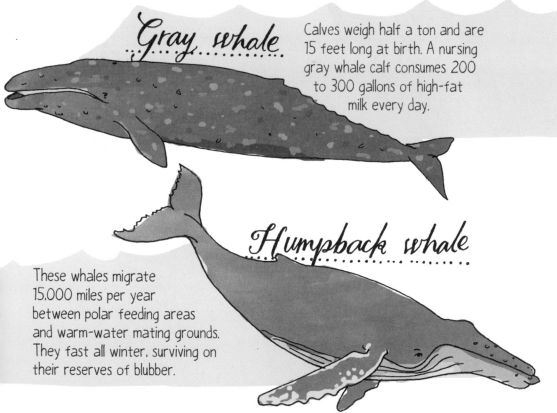

# Gray whale

Calves weigh half a ton and are 15 feet long at birth. A nursing gray whale calf consumes 200 to 300 gallons of high-fat milk every day.

# Humpback whale

These whales migrate 15,000 miles per year between polar feeding areas and warm-water mating grounds. They fast all winter, surviving on their reserves of blubber.

CHAPTER 6

# A Little Bird Told Me

# ANATOMY OF A BIRD

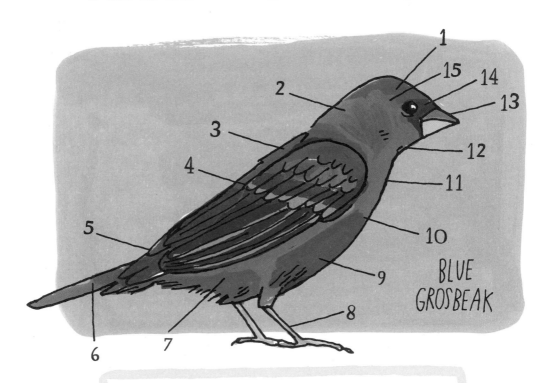

BLUE GROSBEAK

1. crown
2. nape
3. back
4. wing bar
5. rump
6. tail
7. flank
8. tarsus
9. side
10. breast
11. throat
12. chin
13. bill
14. lore (area between eye and bill)
15. ear patch

# ❧ A BEVY OF BIRDS ❧

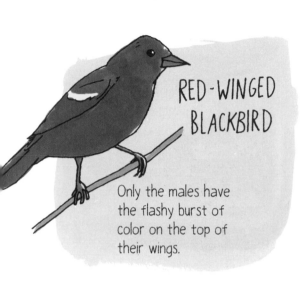

## RED-WINGED BLACKBIRD

Only the males have the flashy burst of color on the top of their wings.

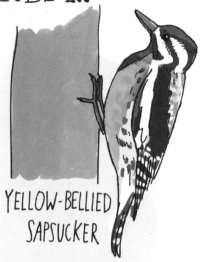

## YELLOW-BELLIED SAPSUCKER

One-fifth of their diet comes from the sap collected from drilling tiny holes in trees.

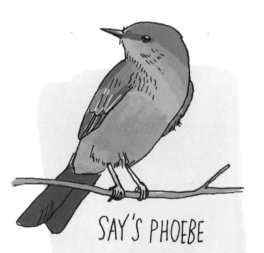

## SAY'S PHOEBE

Look for their cup-shaped nests attached to bridges, canyon walls, and wells.

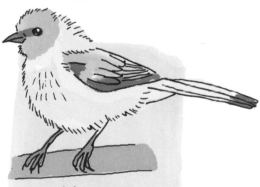

## VERDIN

These desert dwellers build round nests covered with thorns.

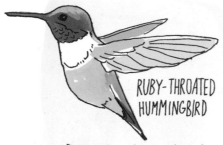

### RUBY-THROATED HUMMINGBIRD

During its winter migrations to Central America, it may fly over the entire Gulf of Mexico nonstop.

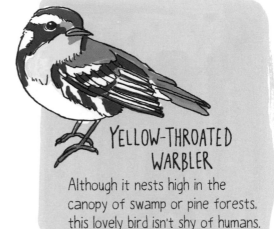

### YELLOW-THROATED WARBLER

Although it nests high in the canopy of swamp or pine forests, this lovely bird isn't shy of humans.

### SCARLET TANAGER

They provide an important service to the oaks they call home by eating damaging caterpillars and beetles.

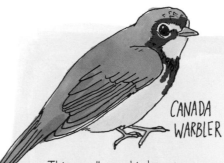

### CANADA WARBLER

This small songbird nests near the ground in decaying logs.

### MOUNTAIN CHICKADEE

Mated pairs of chickadees may join forest flocks containing several different species of small birds.

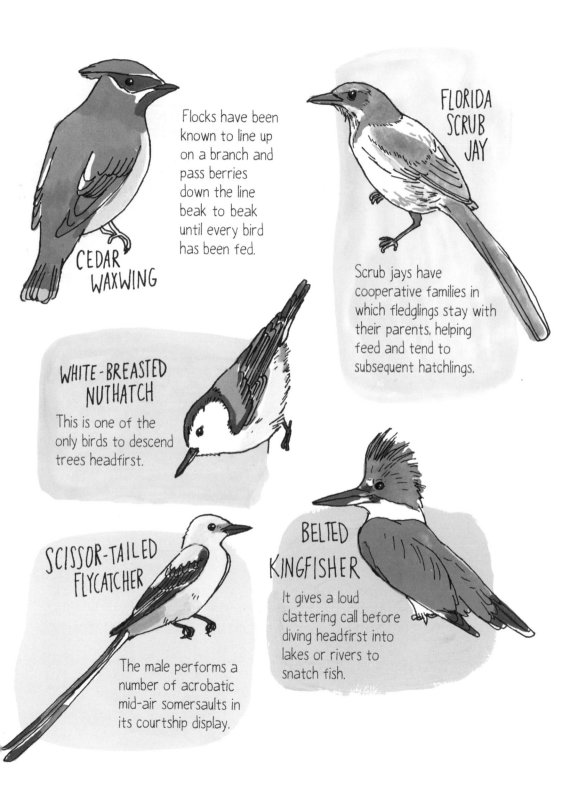

Flocks have been known to line up on a branch and pass berries down the line beak to beak until every bird has been fed.

**CEDAR WAXWING**

**FLORIDA SCRUB JAY**

Scrub jays have cooperative families in which fledglings stay with their parents, helping feed and tend to subsequent hatchlings.

**WHITE-BREASTED NUTHATCH**

This is one of the only birds to descend trees headfirst.

**SCISSOR-TAILED FLYCATCHER**

The male performs a number of acrobatic mid-air somersaults in its courtship display.

**BELTED KINGFISHER**

It gives a loud clattering call before diving headfirst into lakes or rivers to snatch fish.

## CLARK'S NUTCRACKER

This bird has a pouch beneath its tongue that can hold up to 150 pine seeds, its primary food.

## BROWN-CAPPED ROSY FINCH

Finches have a "bouncing" flight with bouts of flapping interspersed with swooping glides with closed wings.

## HOODED ORIOLE

Orioles weave distinctive nests shaped like deep purses hanging from branches.

## GREAT CRESTED FLYCATCHER

Flycatchers prefer to include snake skins in nest linings but may substitute strips of plastic bags.

## BLACK-AND-WHITE WARBLER

During the breeding season, male warblers have much more ostentatious plumage than females, but they revert to drab colors in the fall.

## MOUNTAIN BLUEBIRD

Fiercely protective, a bluebird may hunker down in its nest even when approached by humans.

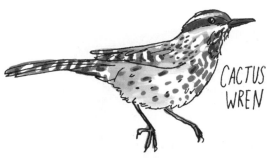

## CACTUS WREN

This wren obtains all the liquid it needs from its diet of insects, with some seeds, fruit, and small reptiles.

## STELLER'S JAY

North America's largest jay is also the noisiest, with an energetic common call: "Shaack! Shaack! Shaack!"

## GILA WOODPECKER

Abandoned nest cavities in saguaro cacti become home to rats, snakes, and other animals.

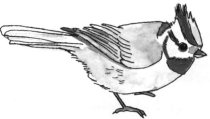

## BRIDLED TITMOUSE

Titmice tend to perform acrobatics while feeding: flipping, swinging, and hanging upside down.

# Kinds of Feathers

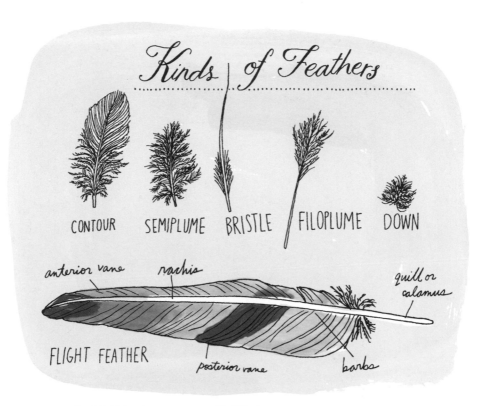

CONTOUR    SEMIPLUME    BRISTLE    FILOPLUME    DOWN

anterior vane    rachis    quill or calamus

FLIGHT FEATHER

posterior vane    barbs

# Feathers on a Bird

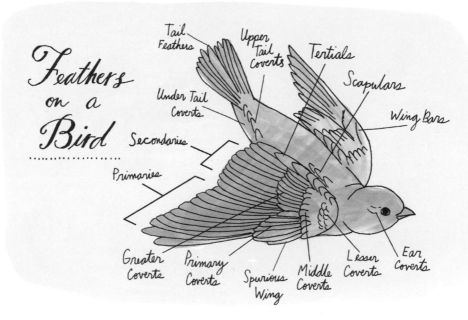

Tail Feathers

Upper Tail Coverts

Tertials

Scapulars

Under Tail Coverts

Wing Bars

Secondaries

Primaries

Greater Coverts

Primary Coverts

Spurious Wing

Middle Coverts

Lesser Coverts

Ear Coverts

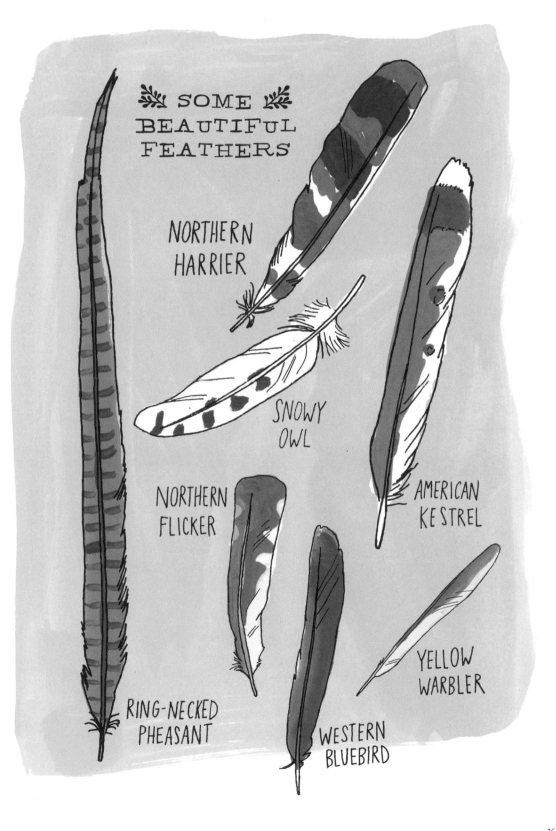

SOME BEAUTIFUL FEATHERS

NORTHERN HARRIER

SNOWY OWL

NORTHERN FLICKER

AMERICAN KESTREL

RING-NECKED PHEASANT

WESTERN BLUEBIRD

YELLOW WARBLER

# BIRDCALLS

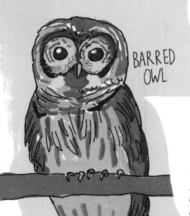

"birdie-birdie-birdie"

BARRED OWL

NORTHERN CARDINAL

"Who cooks for you all?"

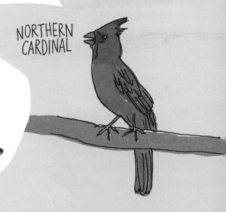

Songbirds of the same species don't all sing the same song. Geographically isolated populations often develop distinct vocal repertories that, in time, can form different "dialects" within a species.

"but-I-DO-love you"

EASTERN MEADOWLARK

"Germany-Germany-Germany"

CAROLINA WREN

Songbirds learn their songs rather than inherit them. They make an innate array of sounds, but young birds learn to sing by listening to the older birds around them.

"witchity-witchity-witchity"

Youngsters spend their first winter dreaming about those songs (literally: studies have found that they "practice" in their sleep). In the spring they begin to sing them aloud. And since most songbirds return each year to the same area, little pockets of geographically distinct songs develop.

COMMON YELLOWTHROAT

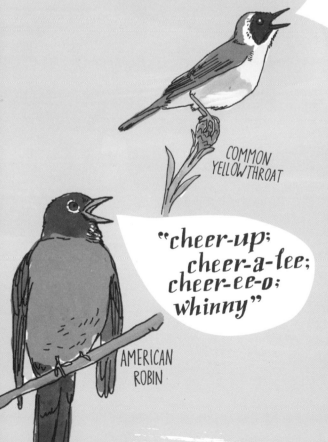

"cheer-up; cheer-a-lee; cheer-ee-o; whinny"

AMERICAN ROBIN

# A VARIETY OF NESTS

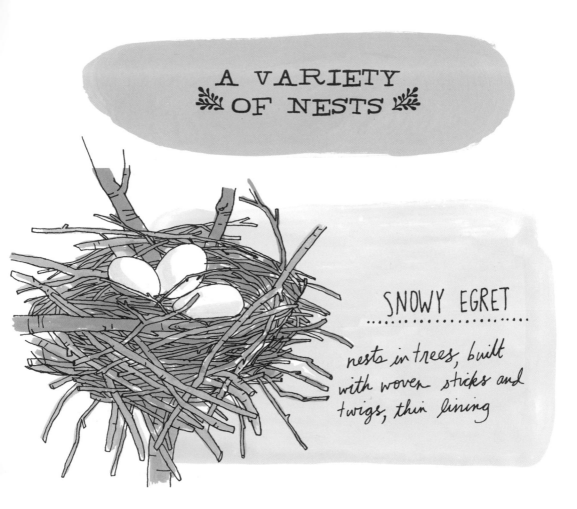

## SNOWY EGRET

nests in trees, built with woven sticks and twigs, thin lining

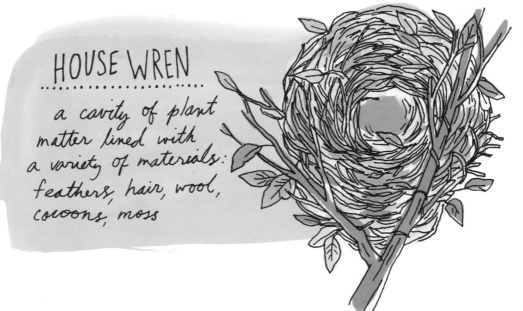

## HOUSE WREN

a cavity of plant matter lined with a variety of materials: feathers, hair, wool, cocoons, moss

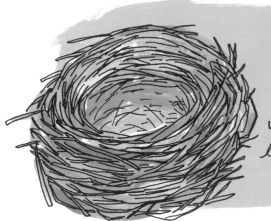

## SONG SPARROW

a cup of dead grasses, weeds, and bark pieces, lined with thin grasses

## ANNA'S HUMMINGBIRD

a cup made of stems and plant down, held together with spider webs, lined with plant down and feathers, decorated with lichen and moss

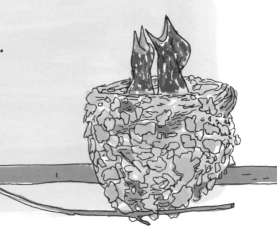

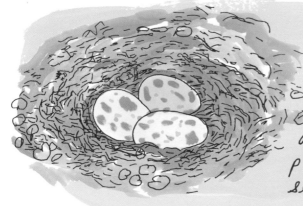

## GREATER BLACK-BACKED GULL

a scrape of dead plant matter, mosses, seaweed, feathers

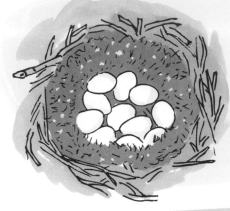

## MALLARD DUCK

a hollow of down,
plant debris, grasses,
and leaves

## BARN
## SWALLOW

a cup of mud
pellets and fibers,
lined with feathers;
built in caves or
rafters of buildings

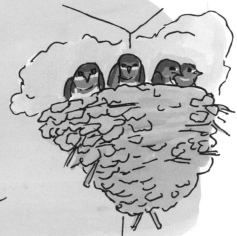

## VERDIN

a spherical insulated nest
of sticks with thorns all
around them, lined with
spider webs and fine
grasses, and then a thick
layer of feathers and
plant down

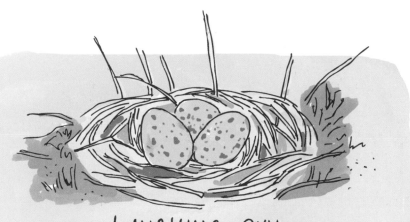

## LAUGHING GULL
· · · · · · · · · · · · · · · · · · · · · · · ·

arranged in beach grass
or found in a shallow hole
in the sand, lined with grasses
and sticks

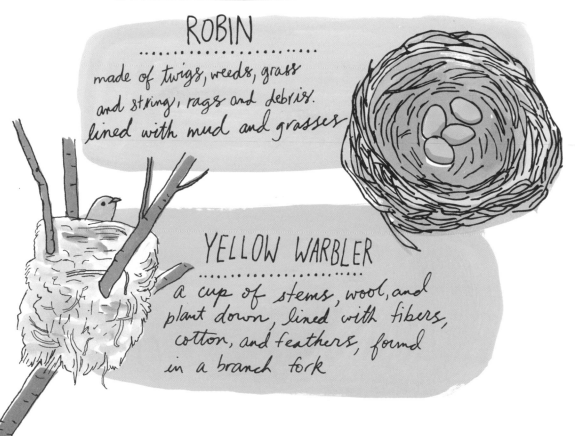

## ROBIN
· · · · · · · · · · · · · · · · · · · · · · · ·

made of twigs, weeds, grass
and string, rags and debris.
lined with mud and grasses

## YELLOW WARBLER
· · · · · · · · · · · · · · · · · · · · · · · ·

a cup of stems, wool, and
plant down, lined with fibers,
cotton, and feathers, found
in a branch fork

CANADA
WARBLER

Extraordinary
eggs

HOUSE
FINCH

EASTERN
SCREECH
OWL

CACTUS
WREN

CALIFORNIA
THRASHER

AMERICAN
GOLDEN PLOVER

COMMON
GRACKLE

HOODED
ORIOLE

BLUE
JAY

4³⁄₈ × 3″

5⁄8 × 1⁄2″

TRUMPTETER
SWAN

BARN
SWALLOW

NORTHERN
CARDINAL

CEDAR
WAXWING

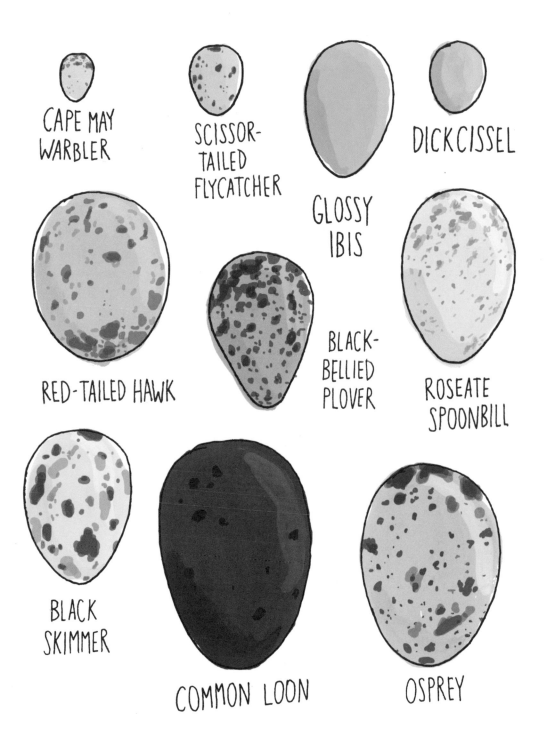

CAPE MAY WARBLER

SCISSOR-TAILED FLYCATCHER

GLOSSY IBIS

DICKCISSEL

RED-TAILED HAWK

BLACK-BELLIED PLOVER

ROSEATE SPOONBILL

BLACK SKIMMER

COMMON LOON

OSPREY

# INTRIGUING BIRD
## 🌿 BEHAVIOR 🌿

## Courting

Most bird species breed in the spring, with males displaying courtship behavior such as specialized songs, dances, or acrobatic flights. Females select males that demonstrate their health and vigor in these displays, thereby ensuring healthy offspring.

## Mating

Both male and female birds have a single opening called a cloaca that is used for both waste excretion and reproduction. Males store sperm in their cloaca until a female becomes receptive. When mating occurs, the male typically balances on the back of the hunching female and arches his body so his cloaca can rub against hers. Mating may take only a second or two but is often repeated.

# Preening

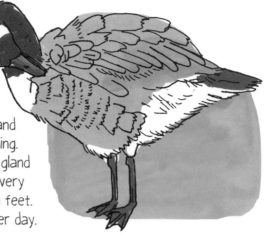

Birds clean, realign, protect, repair, and waterproof their feathers by preening. Most birds gather oil from a special gland near their tails and spread it over every feather with their beaks, heads, and feet. Birds may preen for several hours per day.

# Bathing

Birds clean their feathers and dislodge parasites by bathing in either pools of water or shallow depressions of dust.

# Anting

Several species of birds will lie near anthills with their wings spread, allowing the ants to infiltrate their feathers. The ants leave traces of formic acid, which repels parasites.

# Using Tools

Some species of finch use twigs to gather insects from holes in logs or tree trunks. Crows also do this, and some have learned to open nuts by dropping them in front of moving cars. Herons have been observed using bread, left by humans feeding ducks, as bait for fish.

# ❧ BIRDS OF PREY ❧

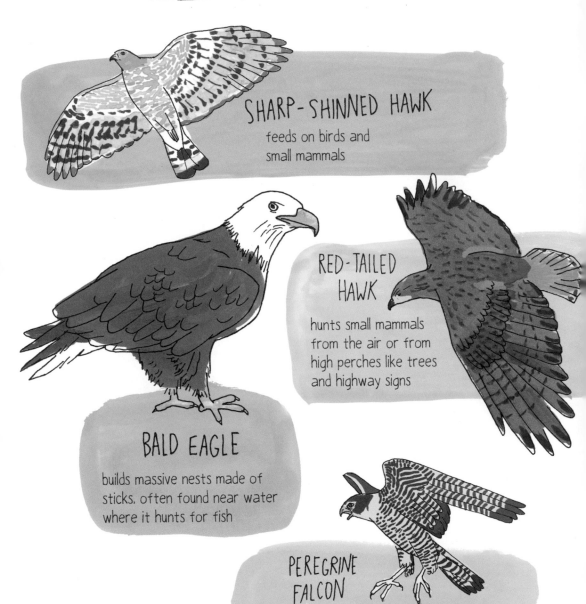

## SHARP-SHINNED HAWK
feeds on birds and
small mammals

## RED-TAILED
## HAWK
hunts small mammals
from the air or from
high perches like trees
and highway signs

## BALD EAGLE
builds massive nests made of
sticks, often found near water
where it hunts for fish

## PEREGRINE
## FALCON
has been recorded diving at
over 250 miles per hour

## SWAINSON'S HAWK

hunts from the ground for gophers, mice, and even grasshoppers

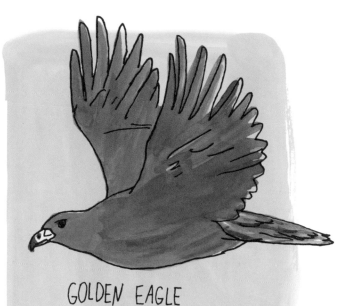

## GOLDEN EAGLE

powerful enough to hunt young deer and other large mammals

## NORTHERN HARRIER

also called the marsh hawk, builds nests on the ground

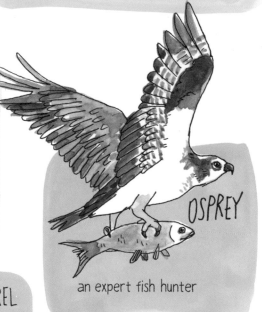

## OSPREY

an expert fish hunter

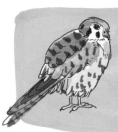

## AMERICAN KESTREL

hovers above small mammals before quickly diving for the kill

# ❧ OWLS ❧

Owls have very large eyes that cannot move. Instead, they can turn their heads around almost 270 degrees, much more than most other animals. The faces of most owls are concave discs, ideal for focusing the sounds of night-scurrying prey.

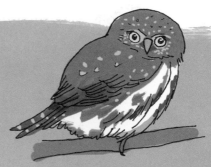

## PYGMY OWL
only 6 inches in length, nests in holes in evergreens

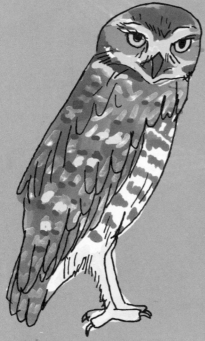

## BURROWING OWL
lives in large underground burrows lined with feathers and plant matter

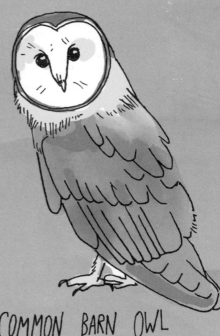

## COMMON BARN OWL
can locate prey in complete darkness by sound alone

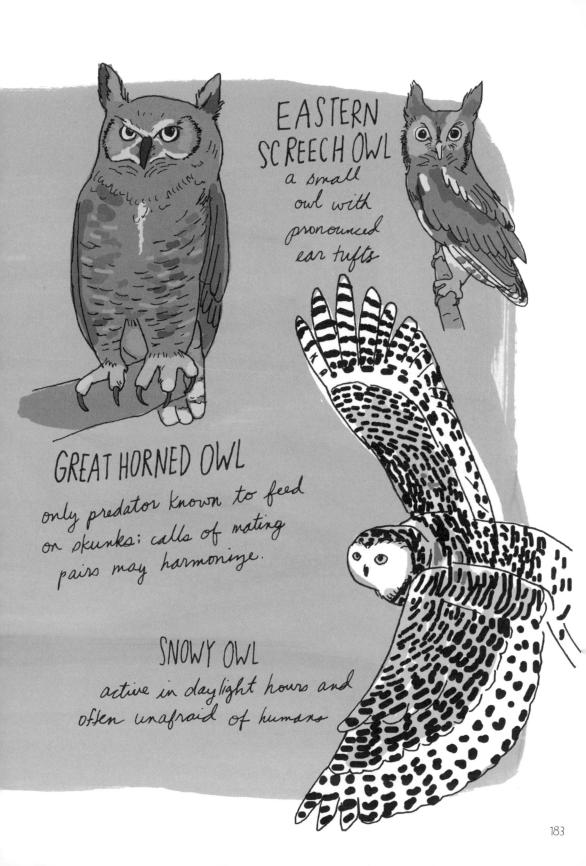

EASTERN SCREECH OWL
a small owl with pronounced ear tufts

GREAT HORNED OWL

only predator known to feed on skunks; calls of mating pairs may harmonize.

SNOWY OWL
active in daylight hours and often unafraid of humans

# BIG BIRDS

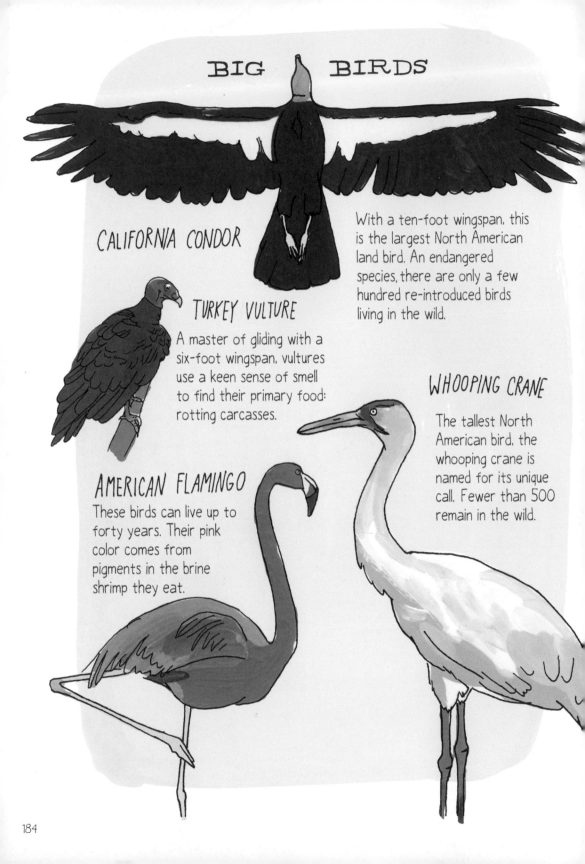

## CALIFORNIA CONDOR

With a ten-foot wingspan, this is the largest North American land bird. An endangered species, there are only a few hundred re-introduced birds living in the wild.

## TURKEY VULTURE

A master of gliding with a six-foot wingspan, vultures use a keen sense of smell to find their primary food: rotting carcasses.

## WHOOPING CRANE

The tallest North American bird, the whooping crane is named for its unique call. Fewer than 500 remain in the wild.

## AMERICAN FLAMINGO

These birds can live up to forty years. Their pink color comes from pigments in the brine shrimp they eat.

# A Variety of Beaks

## WHITE-THROATED SPARROW

great for crushing seeds
and pecking at bark
to uncover hiding insects

## RINGED KINGFISHER

wedge shape creates
no splash when entering
the water

## MALLARD DUCK

used for skimming
in shallow waters

## BALD EAGLE

hooked for tearing up prey

## RED CROSSBILL

helps with prying
apart scales of a
pinecone

## RUBY-THROATED HUMMINGBIRD

long, to probe
into flowers

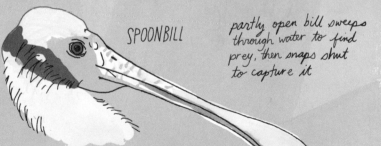

## SPOONBILL

partly open bill sweeps
through water to find
prey, then snaps shut
to capture it

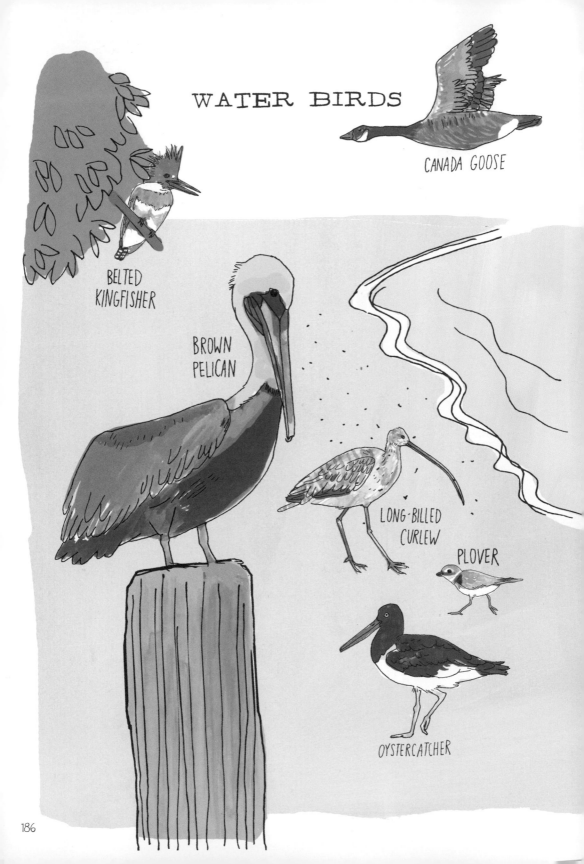

# WATER BIRDS

CANADA GOOSE

BELTED KINGFISHER

BROWN PELICAN

LONG-BILLED CURLEW

PLOVER

OYSTERCATCHER

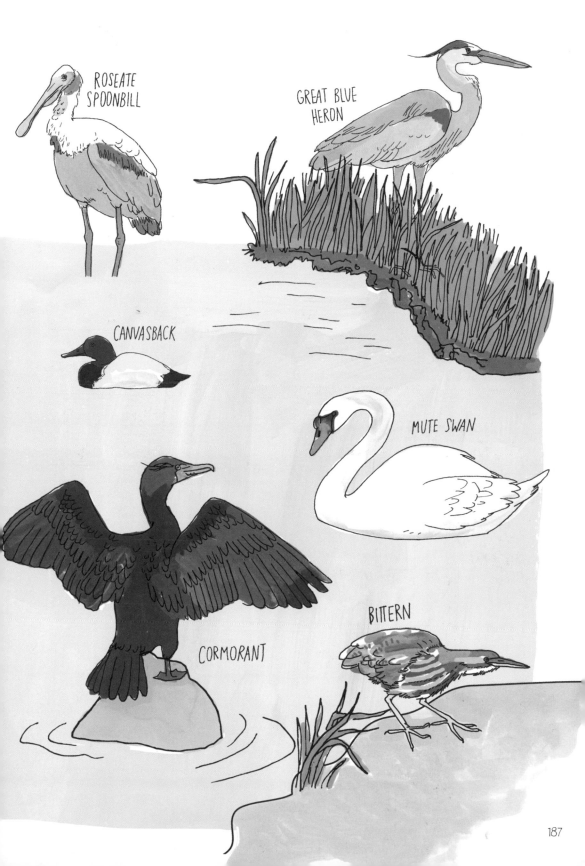

ROSEATE
SPOONBILL

GREAT BLUE
HERON

CANVASBACK

MUTE SWAN

CORMORANT

BITTERN

CHAPTER 7

# Head above Water

# ❧ WATER BODIES ❧

## Ocean

massive bodies of
salt water that
cover nearly
two-thirds of the
earth's surface

*Atlantic
Ocean*

## Sound

a large ocean inlet

## Sea

a large body of salt
water that is smaller
than an ocean and
sometimes bordered
by land

# Bay

a broad sea inlet partially surrounded by land

# Cove

a small bay

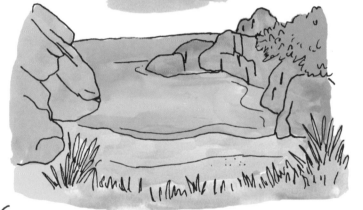

# Tidal Pool

rocky saltwater shore pools that become separate from the ocean during low tide

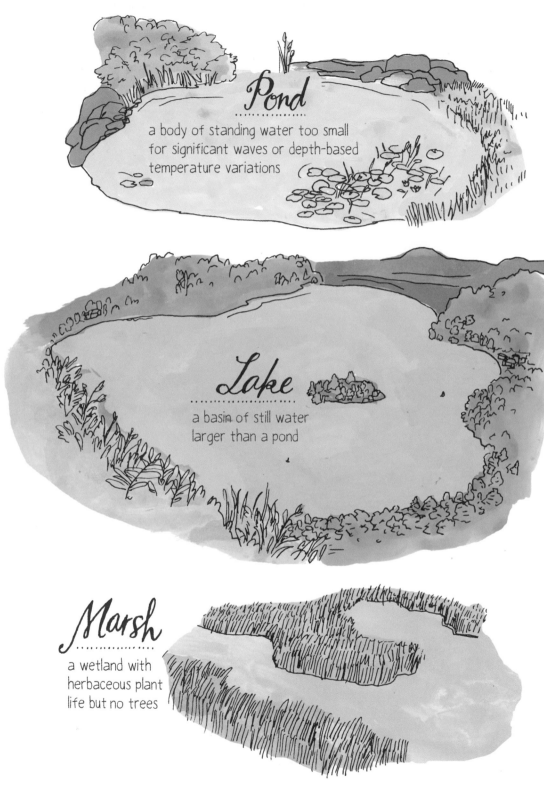

## Pond

a body of standing water too small
for significant waves or depth-based
temperature variations

## Lake

a basin of still water
larger than a pond

## Marsh

a wetland with
herbaceous plant
life but no trees

## River

a natural waterway that flows toward another body of water

## Stream

a small to medium body of flowing water held between banks

## Brook

a small stream

# ECOSYSTEM OF A POND

The rich array of life in a pond ecosystem can be classified into three groups: PRODUCERS, CONSUMERS, and DECOMPOSERS.

Plants are the primary PRODUCERS in ponds and receive energy from the sun.

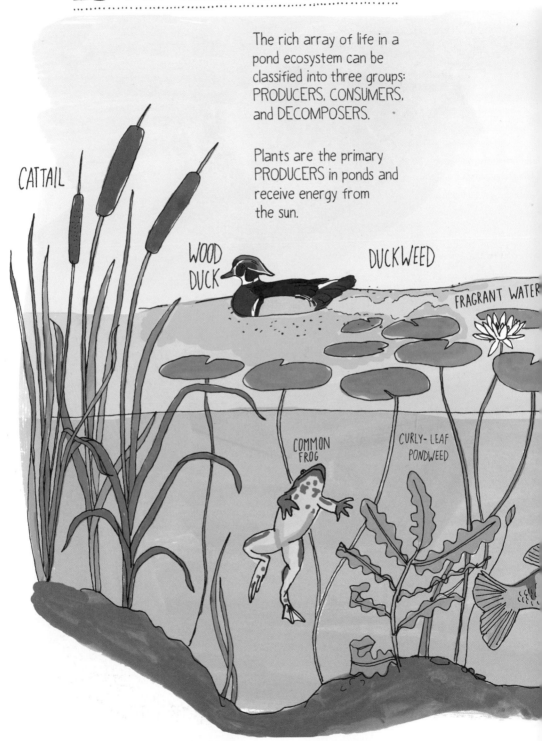

CATTAIL

WOOD DUCK

DUCKWEED

FRAGRANT WATER

COMMON FROG

CURLY-LEAF PONDWEED

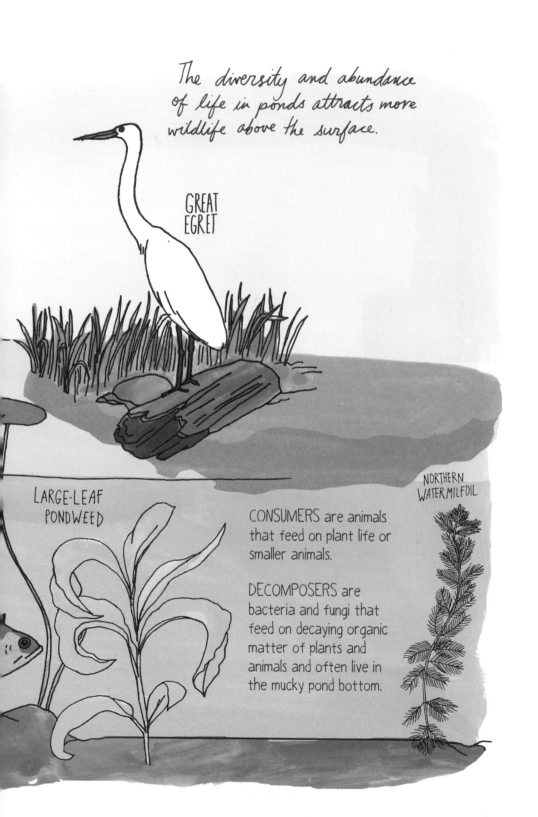

The diversity and abundance of life in ponds attracts more wildlife above the surface.

GREAT EGRET

LARGE-LEAF PONDWEED

NORTHERN WATER MILFOIL

CONSUMERS are animals that feed on plant life or smaller animals.

DECOMPOSERS are bacteria and fungi that feed on decaying organic matter of plants and animals and often live in the mucky pond bottom.

195

# ❊ A FEW FRESHWATER FISH ❊

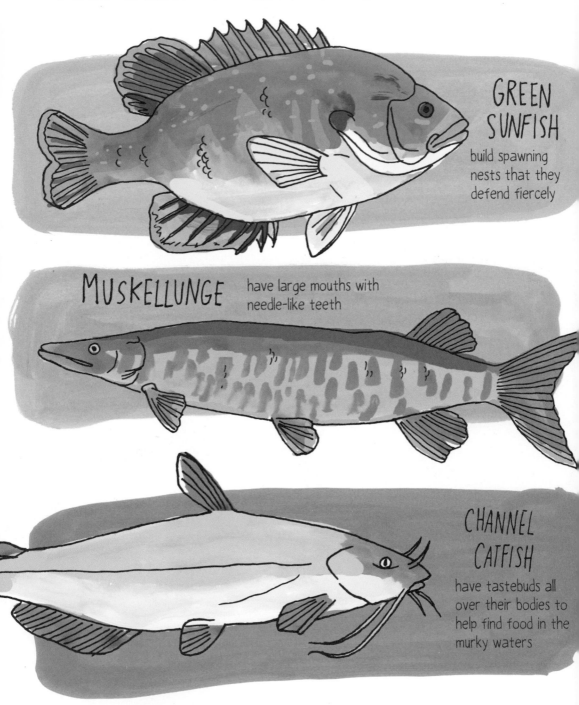

**GREEN SUNFISH** build spawning nests that they defend fiercely

**MUSKELLUNGE** have large mouths with needle-like teeth

**CHANNEL CATFISH** have tastebuds all over their bodies to help find food in the murky waters

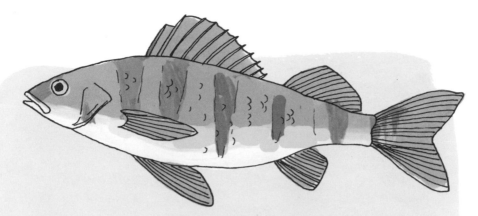

**YELLOW PERCH** live near shore in weedy areas, feed on insects and small fish, and are cannabalistic

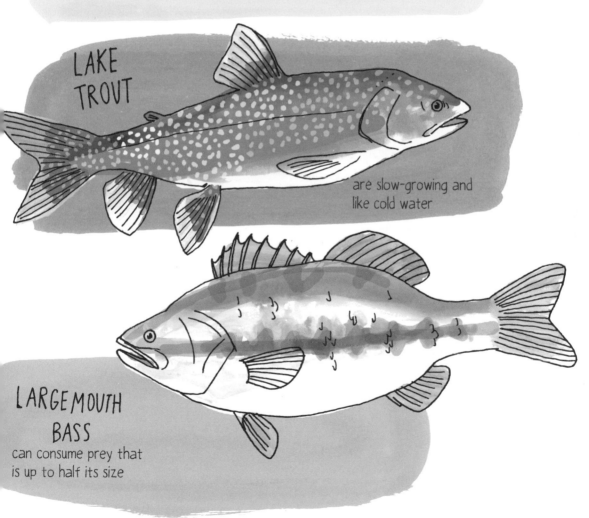

**LAKE TROUT** are slow-growing and like cold water

**LARGEMOUTH BASS** can consume prey that is up to half its size

# Life Cycle of a Salmon

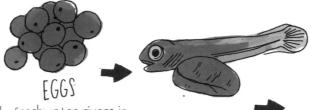

### EGGS

In freshwater rivers in the autumn, female salmon dig holes, or redds, with their tails in gravelly river beds to lay eggs. Male salmon deposit their sperm, called milt, over the eggs.

### ALEVIN

6 to 12 weeks later, the eggs hatch and tiny salmon, called alevin, emerge. Alevin hide in the gravel and feed from attached yolk sacs for some weeks.

### FRY

Once the yolk sacs are consumed, young salmon, now called fry, emerge and begin eating tiny invertebrates and even the carcasses of dead adult salmon.

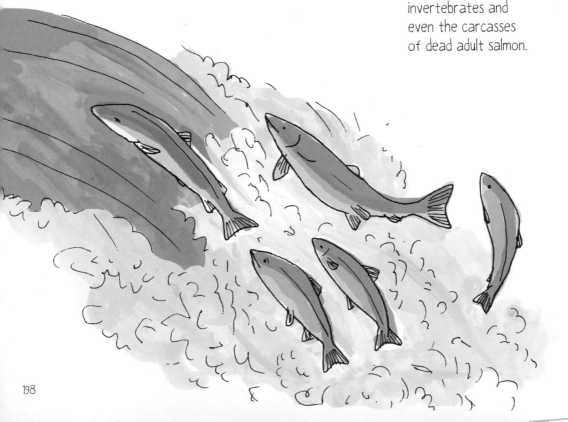

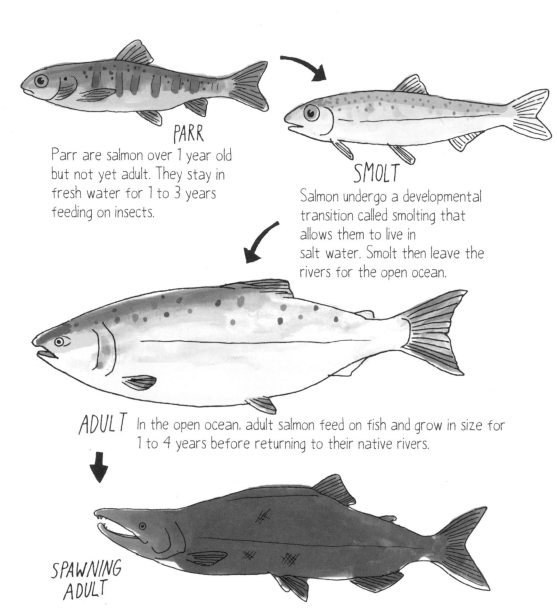

### PARR

Parr are salmon over 1 year old but not yet adult. They stay in fresh water for 1 to 3 years feeding on insects.

### SMOLT

Salmon undergo a developmental transition called smolting that allows them to live in salt water. Smolt then leave the rivers for the open ocean.

### ADULT

In the open ocean, adult salmon feed on fish and grow in size for 1 to 4 years before returning to their native rivers.

### SPAWNING ADULT

Adults return to the site of their birth to spawn, undergoing physical transformation to readapt to fresh water. Their silvery bodies darken as they expend energy to produce eggs and milt. Soon after spawning, adult salmon die, creating a rich source of food for many other animals, including their future offspring.

# ❧ WATER BUGS ❧

### MAYFLY

Because its adult lifespan is so short, the mayfly is called a "one-day" fly in some languages.

### GIANT WATER BUG

The eggs are laid on the male's wings and he carries them on his back until they hatch.

### WATER STRIDER

Hairs on their bodies repel water droplets so they can skate on the surface of the water.

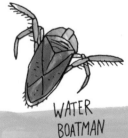

### WATER BOATMAN

Their long, flat bodies enable them to swim on the bottom of ponds and streams.

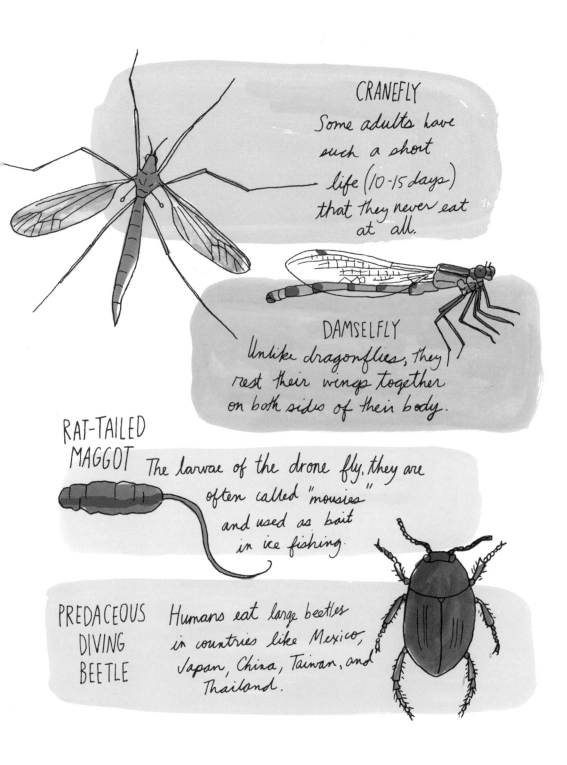

**CRANEFLY**
Some adults have such a short life (10-15 days) that they never eat at all.

**DAMSELFLY**
Unlike dragonflies, they rest their wings together on both sides of their body.

**RAT-TAILED MAGGOT**
The larvae of the drone fly, they are often called "mousies" and used as bait in ice fishing.

**PREDACEOUS DIVING BEETLE**
Humans eat large beetles in countries like Mexico, Japan, China, Taiwan, and Thailand.

# TOAD     VS.     FROG

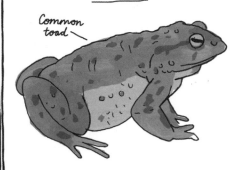

Common toad

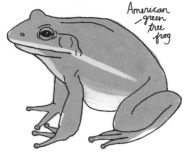

American green tree frog

- short legs for walking and hopping

- dry, bumpy skin

- stays mostly on land

- no teeth

- non-bulging eyes

- eats insects, slugs, and worms

- long legs for jumping and swimming

- smooth, wet skin

- stays mostly in water

- tiny, sharp cone teeth on the upper jaw

- bulging eyes

- eats insects, snails, worms, and tiny fish

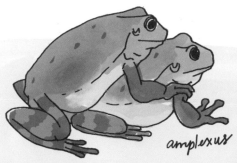

amplexus

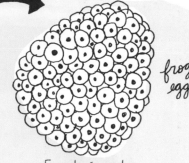

frog eggs

Following loud and elaborate courtship displays in the spring, frogs mate in the water in an embrace called amplexus that may last several days.

Female frogs lay sticky clusters of eggs in calm water.

## Life Cycle of a Frog

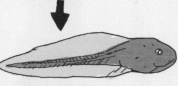

At 12 weeks, froglets have absorbed all but a stub of their tails.

Tadpoles emerge after a week or two.

Tadpoles have rudimentary gills. They may stick themselves to plants until they are strong enough to swim and begin eating algae.

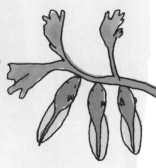

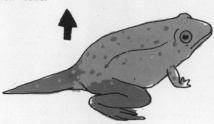

By 9 weeks old, they look like tiny frogs with long tails.

From 6 to 9 weeks after hatching, arms and legs grow elbows-first from the tadpole's sides.

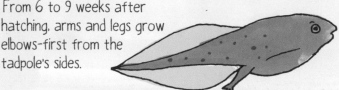

# TIDAL ZONE ECOSYSTEM

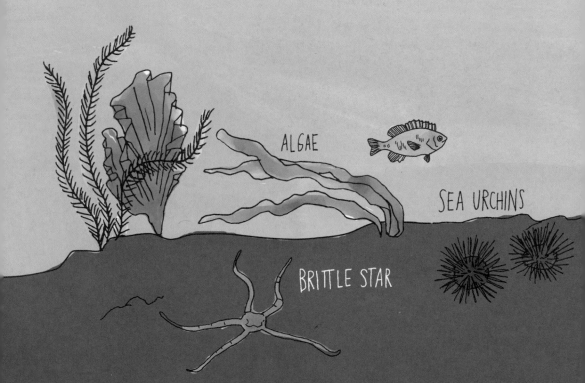

*Splash Zone*

*High Tide Zone*

*Low Tide Zone*

ALGAE

SEA URCHINS

BRITTLE STAR

SEA GULLS

STRIPED SHORE CRABS

TURBAN SNAIL

BARNACLES

OYSTERS

Small changes in elevation reveal profound differences in species distribution in tidal zones.

MUSSELS

LIMPETS

OPALEYE
ANEMONE

WHELK

HERMIT CRAB

SEA STARS

SPONGES

SEA CUCUMBER

# ❧ FANTASTIC SALTWATER FISH ❧

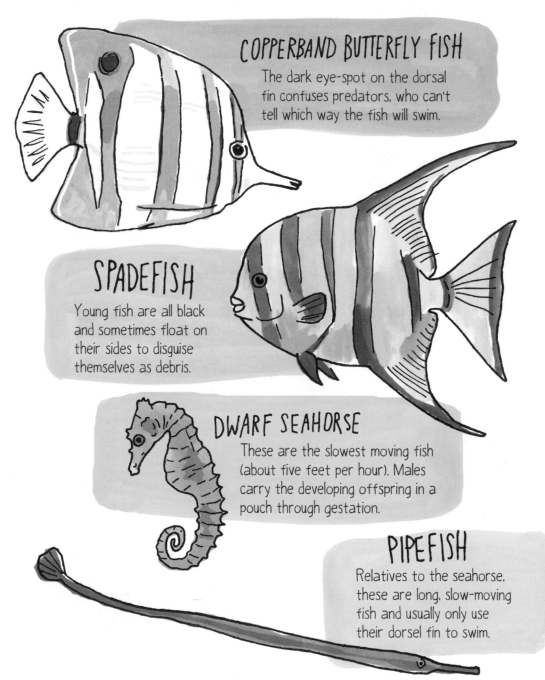

### COPPERBAND BUTTERFLY FISH

The dark eye-spot on the dorsal fin confuses predators, who can't tell which way the fish will swim.

### SPADEFISH

Young fish are all black and sometimes float on their sides to disguise themselves as debris.

### DWARF SEAHORSE

These are the slowest moving fish (about five feet per hour). Males carry the developing offspring in a pouch through gestation.

### PIPEFISH

Relatives to the seahorse, these are long, slow-moving fish and usually only use their dorsel fin to swim.

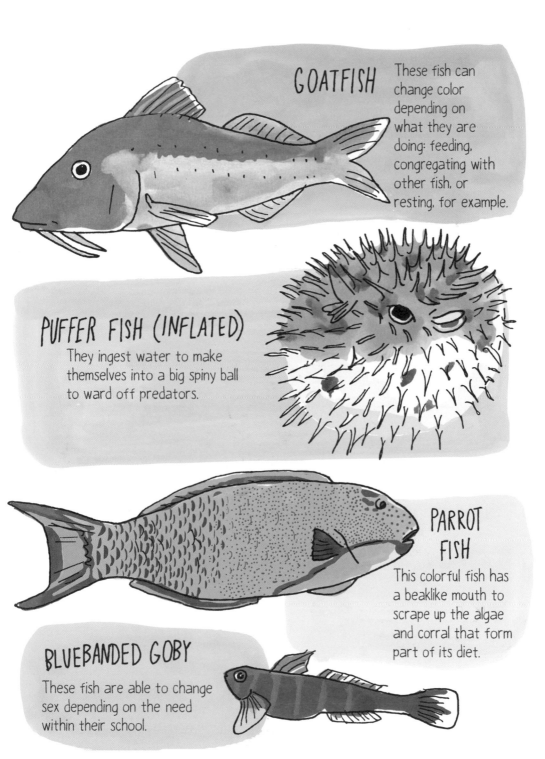

## GOATFISH

These fish can change color depending on what they are doing: feeding, congregating with other fish, or resting, for example.

## PUFFER FISH (INFLATED)

They ingest water to make themselves into a big spiny ball to ward off predators.

## PARROT FISH

This colorful fish has a beaklike mouth to scrape up the algae and corral that form part of its diet.

## BLUEBANDED GOBY

These fish are able to change sex depending on the need within their school.

# ANATOMY OF A JELLYFISH

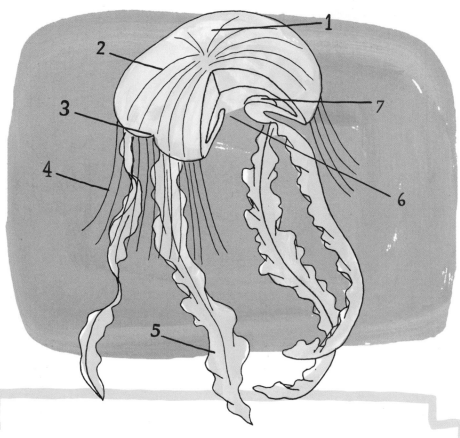

1. **bell** - umbrella-shaped body that contracts and expels water from the cavity underneath to propel the jellyfish

2. **canal** -a series of tubes that run along the bell to distribute nutrients throughout the body in what's called extracellular digestion

3. **eyespot** - light-sensitive spots on the rim of the bell

4. **tentacle** - used for touching

5. **oral arm** - injects the prey with venom

6. **mouth** -- prey goes through here to the gastric cavity

7. **gonad** - reproductive organs that produce sperm and/or egg cells

## LION'S MANE

This is the largest known species, with tentacles as long as 100 feet.

## MOON JELLYFISH

They tend to stay close to the surface of the water, making them easy prey for large fish, turtles, and the occasional marine bird.

## ATLANTIC SEA NETTLE

Unlike other species of jellyfish who only eat plankton, sea nettles have been known to prey on minnows, worms, and mosquito larvae by stinging them with their powerful venom.

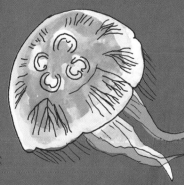

## PORTUGUESE MAN-OF-WAR

This is not a jellyfish but a siphonophone, an organism made up of many highly specialized minute individuals called zooids.

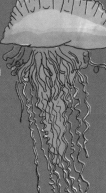

## FRESHWATER

These tiny jellyfish (1 inch big) can be found in almost every state in America and almost every continent.

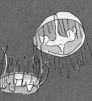

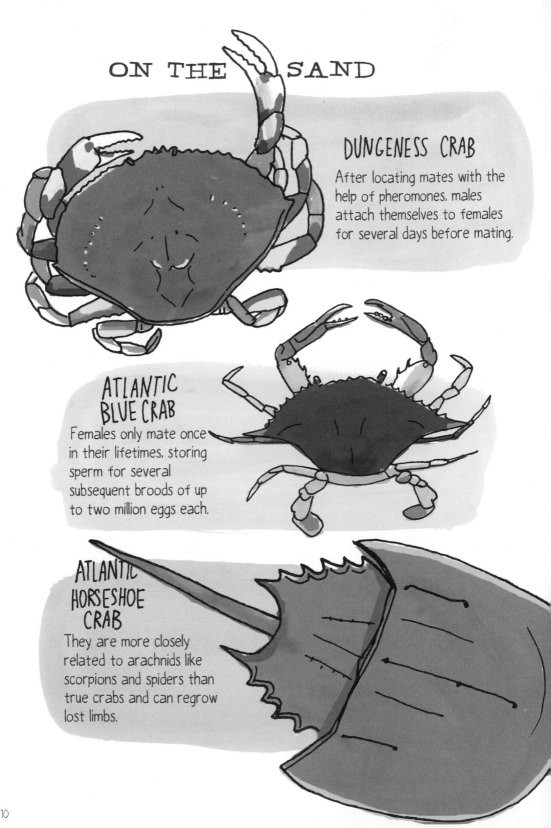

## DUNGENESS CRAB

After locating mates with the help of pheromones, males attach themselves to females for several days before mating.

## ATLANTIC BLUE CRAB

Females only mate once in their lifetimes, storing sperm for several subsequent broods of up to two million eggs each.

## ATLANTIC HORSESHOE CRAB

They are more closely related to arachnids like scorpions and spiders than true crabs and can regrow lost limbs.

## MUSSELS

They attach themselves to underwater rocks with strong byssal threads. These gluey threads are being researched for surgical and industrial applications.

## HERMIT CRAB

They must find a new shell as they grow and often take the shell of a bigger hermit crab that has vacated its shell for another.

## GEODUCK

The largest burrowing clam in the world can be longer than three feet and weigh more than two pounds. It can live hundreds of years.

## OYSTER

Of the many different species of oysters, only a few produce commercial-grade pearls.

## SKATE EGG CASE

These often wash up on the shore after the fish has hatched out.

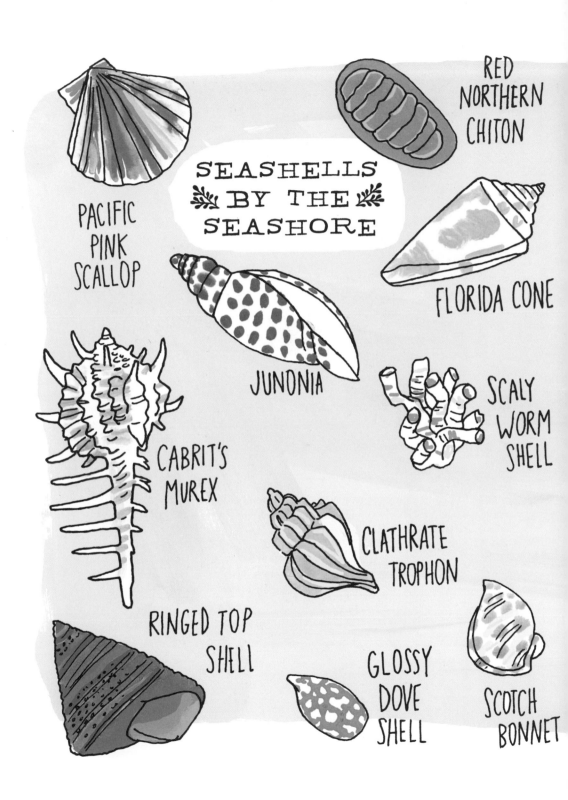

RED NORTHERN CHITON

SEASHELLS
BY THE
SEASHORE

PACIFIC PINK SCALLOP

FLORIDA CONE

JUNONIA

SCALY WORM SHELL

CABRIT'S MUREX

CLATHRATE TROPHON

RINGED TOP SHELL

GLOSSY DOVE SHELL

SCOTCH BONNET

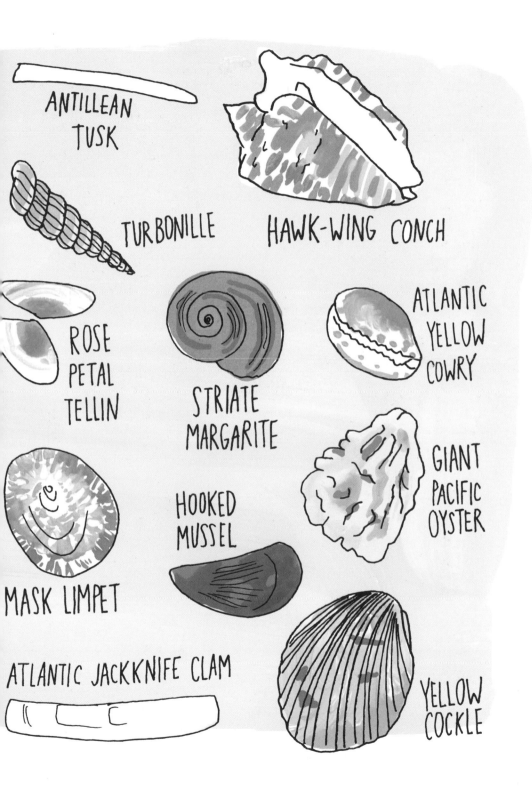

ANTILLEAN TUSK

TURBONILLE

HAWK-WING CONCH

ROSE PETAL TELLIN

STRIATE MARGARITE

ATLANTIC YELLOW COWRY

MASK LIMPET

HOOKED MUSSEL

GIANT PACIFIC OYSTER

ATLANTIC JACKKNIFE CLAM

YELLOW COCKLE

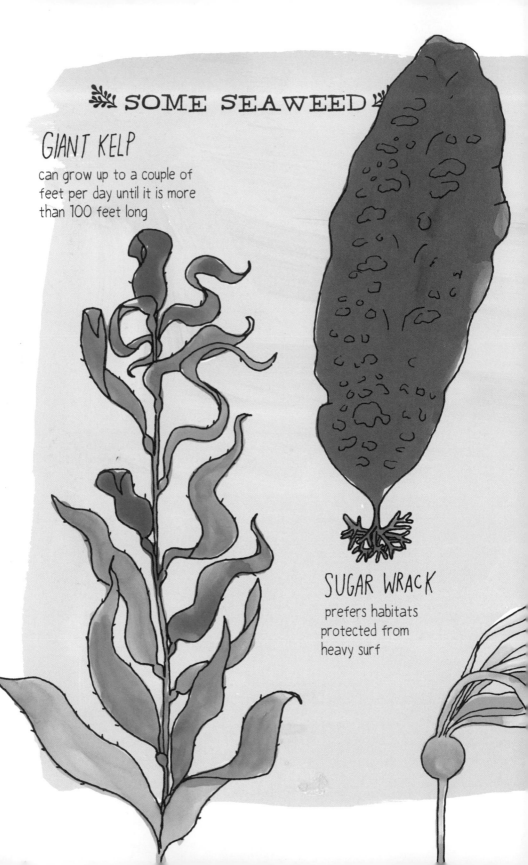

# ✿ SOME SEAWEED ✿

## GIANT KELP

can grow up to a couple of feet per day until it is more than 100 feet long

## SUGAR WRACK

prefers habitats protected from heavy surf

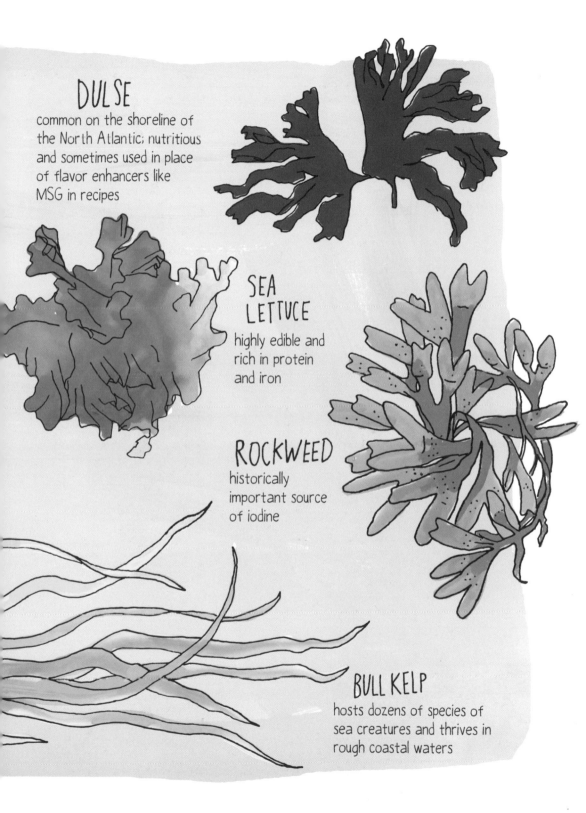

## DULSE
common on the shoreline of the North Atlantic; nutritious and sometimes used in place of flavor enhancers like MSG in recipes

## SEA LETTUCE
highly edible and rich in protein and iron

## ROCKWEED
historically important source of iodine

## BULL KELP
hosts dozens of species of sea creatures and thrives in rough coastal waters

# HARVESTING, PROCESSING, AND EATING SEAWEED

Seaweed is a superfood. It contains calcium, potassium, vitamins A and C, and large amounts of beneficial iodine. In some places, seaweed harvesting is limited by law to certain times of year and you may need a permit or license. Learn how to positively identify useful species and only collect from places with clean water.

Harvesting seaweed is far easier during low tide. Consult official tide tables for your area.

Cut a few seaweed leaves from each main stalk with heavy-duty scissors, without pulling the entire plant out of its mooring. Only harvest actively growing seaweed and avoid seaweed that has been washed up on shore since it can be hard to tell how old it is (though old seaweed is a great soil amendment for your vegetable or flower garden).

Dry seaweed for a few hours on clean, flat surfaces in full sun. A food dehydrator also works well. Store in airtight jars or bags.

Fresh seaweed is delicious with cucumbers, sesame seeds, and rice vinegar. Add dried seaweed to soups, salads, and even trail mix.

# Seaweed Facial Mask

4 LEAVES DRIED KELP
WARM WATER
1 TBSP ALOE VERA GEL
1/4 RIPE BANANA

Grind kelp leaves into a fine powder with your mortar and pestle or coffee grinder. With a fork, mix 1 tbsp. kelp powder, a bit of warm water, and 1 tbsp. aloe vera gel in a bowl. Add the soft banana and mash with a fork. Add warm water as necessary to achieve silky texture.

Apply a thin layer of the seaweed mask to your face and relax for 15-20 minutes. Rinse off with warm water. You can use this natural facial mask every week as part of your beauty routine.

# A NOTE ABOUT CONSERVATION

All parts of the natural world are intimately connected. Small changes to any part of an ecosystem can have profound effects on the health and biodiversity of an entire region.

Though nature is incredibly resilient and adaptable, it is clear that we are in the midst of a period of widespread extinction of species. Most of our natural habitats are threatened by human encroachment. The conservation of expanses of pristine forests, oceans, wetlands, and grasslands is crucial for the survival of threatened species and the future health of our planet.

Your personal commitments to protect wilderness and limit wasteful consumption can make a difference. Help protect the earth's biodiversity and learn more by checking out your local conservation organizations or the Wildlife Conservation Society, the Center for Biological Diversity, the Conservation Fund, Earthworks, the Sierra Club Foundation, and the League of Conservation Voters Education Fund.

No matter where you live, connect with the nature near you in a conscientious way.

# BIBLIOGRAPHY

Alden, Peter, Richard P. Grossenheider, and William H. Burt. Peterson First Guide to Mammals of North America. Boston: Houghton Mifflin, 1987.

Baicich, Paul J., and Colin J. Harrison. Nests, Eggs, and Nestlings of North American Birds. Princeton, NJ: Princeton University Press, 2005.

———. Book of North American Birds: An Illustrated Guide to More Than 600 Species. New York: Reader's Digest Assoc. 2012.

Chesterman, Charles W. The Audubon Society Field Guide to North American Rocks and Minerals. New York: Knopf, 1978.

Coombes, Allen J. Trees. New York: Dorling Kindersley, 2002.

———. Familiar Flowers of North America: Eastern Region. New York: Knopf Distributed by Random House, 1986.

Filisky, Michael, Roger T. Peterson, and Sarah Landry. Peterson First Guide to Fishes of North America. Boston: Houghton Mifflin, 1989.

Hamilton, Jill. The Practical Naturalist: Explore the Wonders of the Natural World. New York: DK Publishing, 2010.

Laubach, Christyna M., René Laubach, and Charles W. Smith. Raptor! : A Kid's Guide to Birds of Prey. North Adams, MA: Storey Publishing, 2002.

Little, Elbert L., Sonja Bullaty, and Angelo Lomeo. The Audubon Society Field Guide to North American Trees. New York: Knopf Distributed by Random House, 1980.

Mäder, Eric. Attracting Native Pollinators: Protecting North America's Bees and Butterflies: the Xerces Society Guide. North Adams, MA: Storey Publishing, 2011.

Mattison, Christopher. Snake. New York: DK Publishing, 2006.

Milne, Lorus J., and Margery J. Milne. The Audubon Society Field Guide to North American Insects and Spiders. New York: Knopf Distributed by Random House, 1980.

Moore, Patrick, and Pete Lawrence. The New Astronomy Guide : Stargazing in the Digital Age. London: Carlton, 2012.

Pyle, Robert M. The Audubon Society Field Guide to North American Butterflies. New York: Knopf Distributed by Random House, 1981.

Rehder, Harald A., and James H. Carmichael. The Audubon Society Field Guide to North American Seashells. New York: Knopf Distributed by Random House, 1981.

Scott, S D., and Casey McFarland. Bird Feathers: A Guide to North American Species. Mechanicsburg, PA: Stackpole Books, 2010.

Sibley, David. The Sibley Guide to Birds. New York: Alfred A. Knopf, 2000.

Spaulding, Nancy E., and Samuel N. Namowitz. Earth Science. Evanston, Ill: McDougal Littell, 2005.

Wernert, Susan J. Reader's Digest North American Wildlife. Pleasantville, NY: Reader's Digest Association, 1982.

..............................................................................................................................

Much of the type in this book was handwritten or uses fonts created from my handwriting. The lettering for titles was based on typefaces Palatino, Archive Antique Extended, Bellevue, and Nelly Script.

# Thank You!

This project took me a very long time, and I feel like I have many people to thank for their help. First and foremost I need to thank my editor, Lisa Hiley, who is amazingly patient, thoughtful, and consistently a pleasure to work with. Thanks to Deborah Balmuth for always believing in my endeavors and being an encouraging voice, Alethea Morrison for her continued design expertise, and the rest of the very kind Storey team. Also special thanks to Pam Thompson for all the initial brainstorming sessions.

Thank you to my friend and partner on the book, John, who provided such great ideas and intriguing facts. He raised the bar with his knowledge, research, and well-crafted words.

This book created a little unexpected collaboration with my mom, who helped paint some of the pages (all of the perfectly detailed ones) when I was running over my deadline, and my dad, who scanned pages for me — it became a family team effort! I feel so grateful to have such continued support from my parents.

My sister is doing incredible projects in Africa, studying primates and educating the community about conservation. Visiting her this year in Uganda has been the most inspiring thing I've done and opened my eyes to see the larger picture. I am in awe of her devotion to such a great cause. You can learn more about her research at nycep.org/rothman

Thank you to my assistant painter and aspiring talent Sarah Green. I wouldn't have finished without her quick hands and uplifting whistling.

Lastly thanks to forever collaborators Jenny and Matt for their consistently spot-on advice on both design and life. And hugs to my friends, Santtu and Rudy!